IMAGES
of America

TEXAS CITY

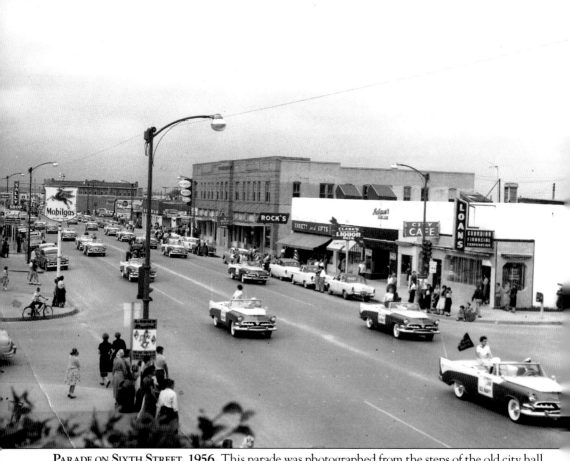

PARADE ON SIXTH STREET, 1956. This parade was photographed from the steps of the old city hall. Parades were common, and the turnout was always good. This parade is believed to have a connection with the Texas City Lions Club and its upcoming minstrel show. (Author's collection.)

IMAGES
of America

TEXAS CITY

Albert L. Mitchell

ARCADIA
PUBLISHING

Published by Arcadia Publishing
Charleston, South Carolina

Printed in the United States of America

Library of Congress Control Number: 2011920848

For all general information, please contact Arcadia Publishing:
Telephone 843-853-2070
Fax 843-853-0044
E-mail sales@arcadiapublishing.com
For customer service and orders:
Toll-Free 1-888-313-2665

Visit us on the Internet at www.arcadiapublishing.com

*To my parents, Johnny and Viola Mitchell, for preserving
Texas City history in both photographs and documents
and for challenging me to learn more about the past*

CONTENTS

ACKNOWLEDGMENTS

The majority of these photographs were taken by Johnny Mitchell, Texas City native and businessman. Photography was his part-time business and full-time hobby. The images of the 1910s were scanned from large panoramic photographs of the Johnny Mitchell collection. The photographs of the 1920s and 1930s were taken by W.O. Wheeless, family member and longtime resident. All others were taken by Johnny Mitchell, and all images appear courtesy of the author.

I wish to thank Linda Turner, coordinator of the Texas City Museum, and Billie Powers, her assistant, for their encouragement and for reviewing the material for historical accuracy.

I also wish to thank Debra Vandergriff and Beverly Mitchell for reviewing the material for grammatical accuracy.

I also wish to thank Dr. Susan Mitchell for reviewing both historical and grammatical accuracy.

INTRODUCTION

Before 1900, investors saw potential in the area known as Shoal Point (later Texas City). These visionaries pictured an industrial complex with a deep-water port and rail system, adjacent to a growing city. The dredging of the channel and the laying of a four-mile track that connected to existing rail lines helped bring their vision to fruition, and Texas City was incorporated in 1911. The dredging of the channel has been ongoing work through the years, and the Texas City Terminal Railway Company has maintained and managed the port and tracks for more than a century.

The Hurricane of 1900 was the first of many 20th-century tragedies to shape Texas City. Unlike Galveston, which lost 6,000 people, Shoal Point (Texas City) lost only three of its 800 residents, although most buildings in the young settlement experienced damage.

The first oil refinery was established in 1908 and was known as the Texas City Refining Company (now Valero Energy Corporation). Other oil refineries and chemical plants were to follow. Some of these were Republic Oil Company, 1931 (now Marathon Oil Company); Pan American Refining Company, 1934 (now British Petroleum); Monsanto Chemicals, 1941 (now Sterling Chemicals); and Union Carbide Corporation, 1940 (now Dow Chemicals).

In 1913, the 2nd Army Division, consisting of approximately 10,000 soldiers, was stationed in Texas City in case of a problem with Mexico during its revolution. At the same time, the 1st Aero Squadron was established, and nearly the entire flying inventory—seven planes—was housed at Bay Street and Ninth Avenue. Some of the officer pilots were trained by the Wright brothers.

In 1915, another tragedy occurred—the Hurricane of 1915. Many buildings in town and most of the Army camp were destroyed, and 12 soldiers were killed in a new building on Sixth Street. This disaster, and the need to relocate closer to the border, spurred the government to move the soldiers out of Texas City, causing an economic downturn.

Because of constant silting of the dredged channel, a five-mile dike, or breakwater, was completed in 1915 to deflect the waters of Galveston Bay out to the Gulf of Mexico. The Texas City Dike has become a major recreational attraction and is often referred to as the world's longest fishing pier.

In 1924, a sugar refinery began operating in new facilities on the waterfront, but it failed in 1930 during the Great Depression. In 1940, Monsanto Chemicals bought their facilities to produce styrene.

By 1932, Galveston County had built a seawall to protect the city from rising water during a hurricane, but future storms proved this was not enough. Another hurricane pounded Texas City in 1943. It did considerable damage to some homes and buildings, but no lives were lost.

In 1947, a catastrophic event occurred when a French cargo ship, the *Grand Camp*, exploded while docked at the port. The ship was loaded with ammonium nitrate and ammunition, and the explosion killed more than 560 people, wounded thousands, and caused damage to every building in town. Monsanto Chemicals, housed in the old sugar refinery complex, was totally destroyed, and many Monsanto employees were killed. Texas City Terminal Railway Company

also lost its facilities and many of its employees. Then, 16 hours after the first explosion, a second ship, the *High Flyer*, exploded, killing at least two and causing more damage. Mayor J.C. Trahan and leaders of Monsanto and the Texas City Terminal Railway Company stated without delay that they would rebuild bigger and safer. It took Texas City years to build back from the disaster of 1947, but the leaders kept their word.

The 1950s started a new era in Texas City. The disaster of 1947 had brought the city together as never before. Every family was affected by loss of life, disabling injuries, loss of property, and psychological stress. Industries rebuilt, the business district began to grow, families continued to make Texas City their home, but the question continued to be asked: "Can it happen again?"

Other storms have plagued the area. Hurricane Carla flooded the city in 1961 and confirmed the need for a new seawall and levee system. Construction began in 1962. The new seawall was tested by Hurricane Alicia in 1983 and Hurricane Ike in 2008 and proved to be more than adequate.

Other accidents have occurred in the industrial area, and many have been killed and injured.

With a history of so many tragedies, why did Texas City continue to grow during the post-disaster years? The answer is in the faces of the people. Many residents returned from World War II and rejoined the community. Since many of their friends did not come back, they were quick to raise their flags when their country was challenged. These were the parents of the baby boomers, and their patriotism was instilled in the next generation. It could be seen in the schools, the Girl Scouts and Boy Scouts, the fraternal orders, and the churches.

Strong families create a strong community, and families became closer. Without the distractions of today, families spent time together and communicated more. Parents were active with their kids in school through the PTA and the Scouts, and a mutual respect existed between school and family.

The church was the gathering place of families, especially when so many loved ones were lost in 1947. It was faith that sustained the widows, the children who lost parents, and the parents who lost children, and it was faith that sustained the churches after losing so many members.

Selflessness is defined as putting other's needs, interests, or wishes before one's own. Texas City survived and flourished because of the unselfish people who gave all they had, expecting nothing in return. This was true of the leadership and average citizens.

It was the people who made Texas City a great place to live, raise a family, and work. That hometown feeling can be seen in their faces. This book paints a picture of Texas City in the 1950s and 1960s; one chapter illustrates the early years. The goal is to illustrate that hometown feeling to readers.

One

THE EARLY YEARS

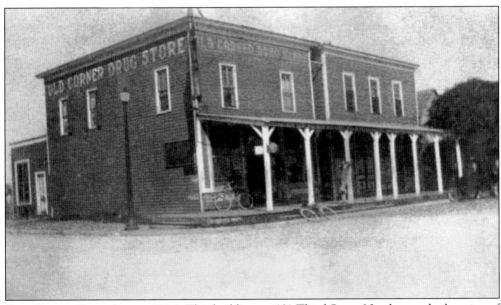

OLD CORNER DRUG STORE, 1926. This building, at 101 Third Street North, was the location of the first post office in 1893, which later moved to Sixth Street. The Old Corner Drug Store was operated at this time by the Agee brothers, before Agee's Drug Store. It was still in operation at this location through the 1940s.

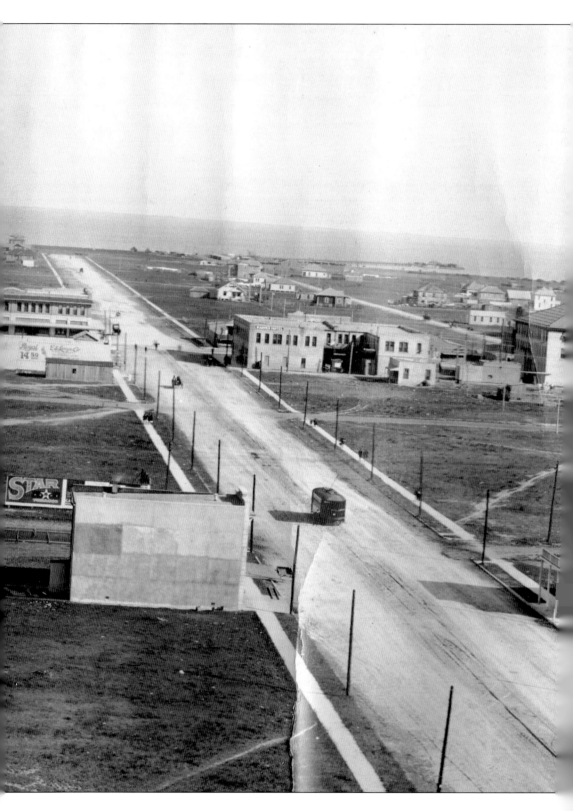

NINTH AVENUE 1913. Texas City was incorporated for only two years when this photograph was taken. Three buildings that are still used today are the McIlvaine Building, the Livingston Ellis Building, and the Mainland Building. Col. H.B. Moore's house can be seen at the end of Ninth Avenue near the bay, and the Wolvin School is the large building in the upper right. Notice the many modes of transportation. The Terrace Drive-In was located in the area to the lower left 40 years after this photograph was taken.

ARMY CAMP, 1913. In 1913, Texas City became the home of nearly 10,000 soldiers of the 2nd Infantry Division, which was five times the population of the city. This brought growth in terms of new businesses, streetcar transportation, and permanent military buildings. After the Hurricane of 1915, in which many soldiers lost their lives, the Army departed Texas City. The streetcar in the photograph above is at the corner of Sixth Street and Eleventh Avenue. Below, a horse and soldiers are heading to the intersection of Ninth Street and Eleventh Avenue.

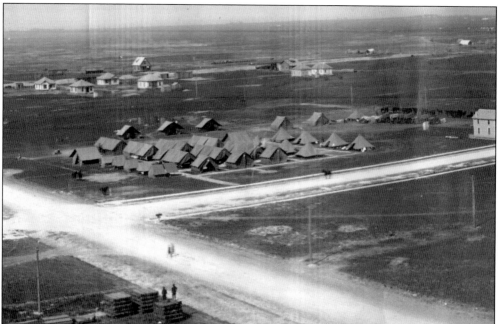

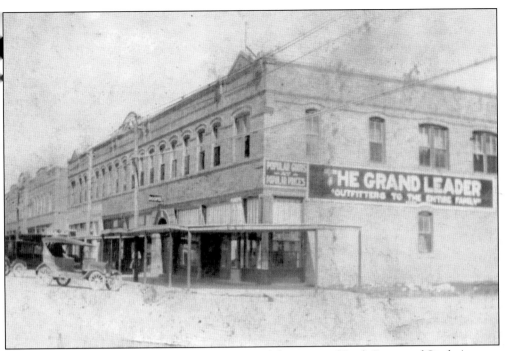

SIXTH STREET, EARLY 1920S. This building occupied the corner of Sixth Street and Sixth Avenue. In a few years, the Grand Leader was replaced by Kilgore Cash Grocery. The small sign reading "Popular Goods for Popular Prices" was used for both stores. Notice the sign advertising rooms.

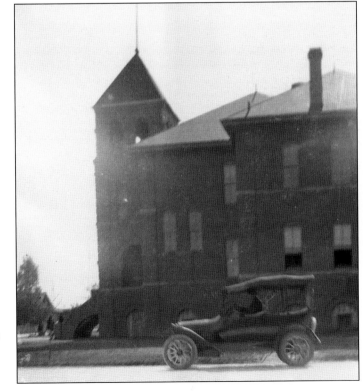

WOLVIN SCHOOL, C. 1926. Wolvin School was completed in 1911 and was named after Capt. A.B. Wolvin, who was active in developing Texas City. It included grades one through 11 and was located at Third Street and Sixth Avenue North. In 1928, it became an elementary school and was demolished after World War II.

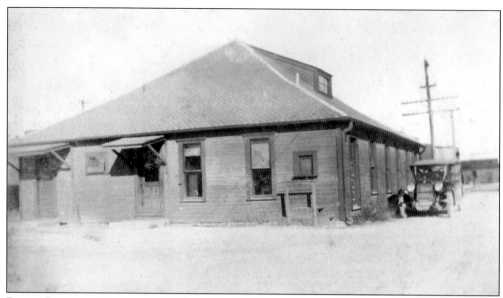

PIERCE REFINERY OFFICE, 1926. Texas City Refining Corporation was the first oil refinery in Texas City, opening in 1908. As the name changed through the years, it became Pierce Petroleum Corporation Refinery, TCR, and was ultimately bought by Valero Energy Corporation. The 1926 Pierce Refinery office is shown.

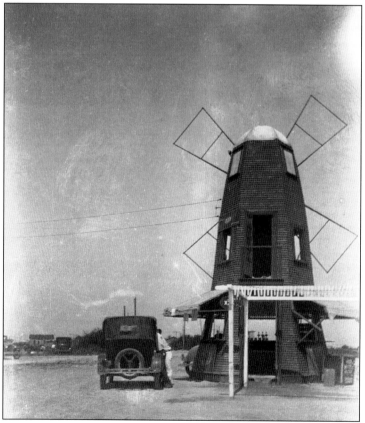

WINDMILL AT DIKE, 1926. This small building was on the dike and is an early example of a drive-in.

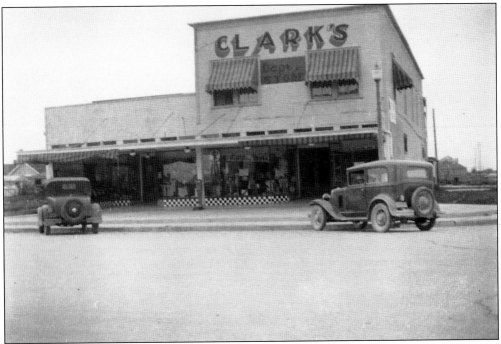

CLARK'S, 1928, 1934. Clark's Department Store opened at the corner of Texas and Fourth Street in 1924. Initially, it was Clark's Shoe Store, but it evolved into a department store by 1928 (above). In 1934, it went through a major renovation and doubled its size (below). After the disaster of 1947, Clark's moved to the 200 block of Sixth Street. This building was occupied in 1948 by businessman Dave Rossman and Dave's Jewelry and Loans. He stayed in business until after 2000. The building was demolished around 2005.

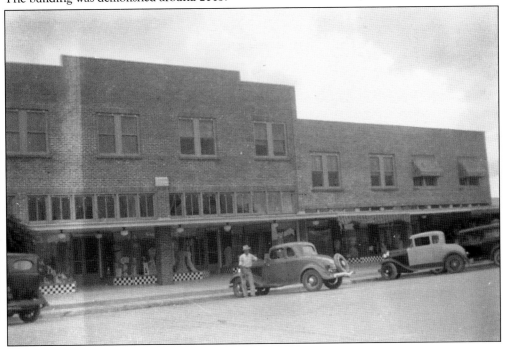

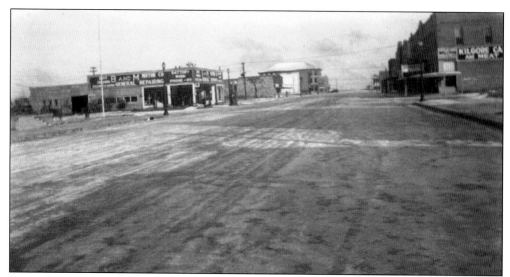

SIXTH STREET, 1929. The old city hall's steps can be seen at the far left, along with its flagpole. B and M Motor Repair was Mainland Motor Company in 1928, and it was complete with gas pumps. By the 1940s, it was the City Hall Service Station, under the Magnolia brand. It was closed by the late 1960s. Farther to the left is the Board of Trade Building (Mainland Building). On the right is Kilgore Cash Grocery, which was damaged so badly by the 1943 hurricane that the top floor was removed. Kilgore Cash Grocery relocated one block south and operated until 1947. In the early 1950s, Rock's Variety and Gifts moved into the left side of this now one-story building. In 1975, a fire destroyed the building. Rock's and Chadwick's Photography Studio did not reopen, but Fork and Spoon Restaurant moved into the McIlvaine Building.

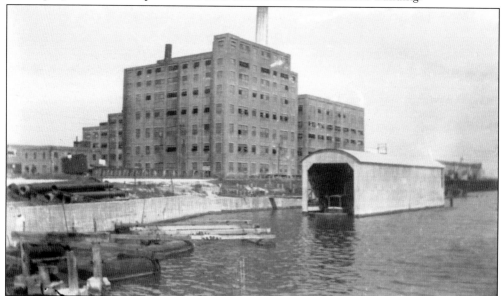

SUGAR REFINERY, 1929. The sugar refinery opened in 1924 and was closed by 1930, a casualty of the Great Depression. In 1941, Monsanto Chemical Company occupied this facility and built a styrene plant on the land. The *Grand Camp* exploded on April 16, 1947, adjacent to this facility. A total of 145 Monsanto employees were killed, and more than 200 were hospitalized with serious injuries.

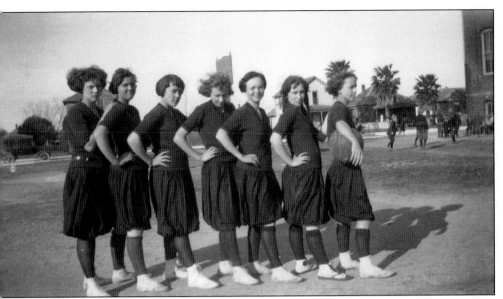

WOLVIN BASKETBALL TEAM, C. 1925. This photograph was taken on the Wolvin School campus. Just before the season was to start in 1925, the league cancelled the county contests, although in years past the Wolvin girls' basketball team had been the county champions every year except one.

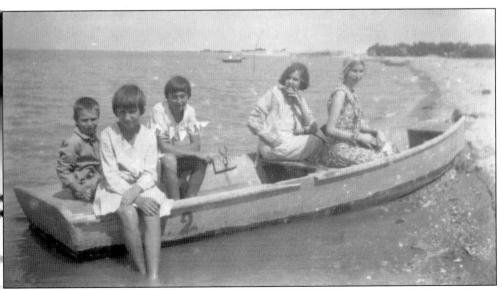

ROW BOAT AT DIKE, C. 1932. Viola Hanna (center) rented a rowboat near the dike with her siblings and grandmother. Notice the other rowboat and the cars driving on the beach, which looks nothing like this now.

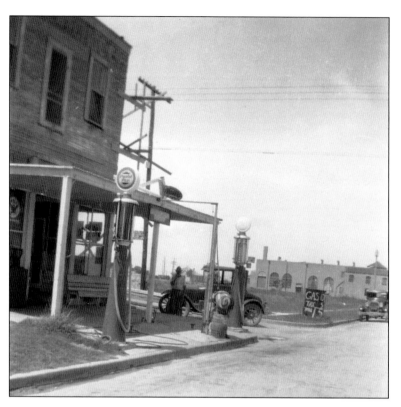

BARBER'S STATION, c. 1934. Barber's Station was located on Sixth Street, on the land that J.C. Penney would occupy in 1948. The J.C. Penney building became the Texas City Museum by 1994.

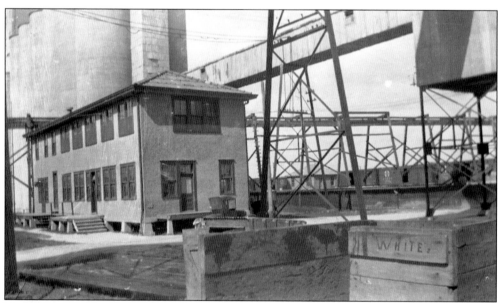

TEXAS CITY TERMINAL OFFICE, c. 1930. The Texas City Terminal Railway Company, the first industry in Texas City, managed the train tracks and the port area. This was its office, located next to the grain elevator. The 1947 disaster destroyed both the office and elevator, killed 46 employees—including the president—and injured 125.

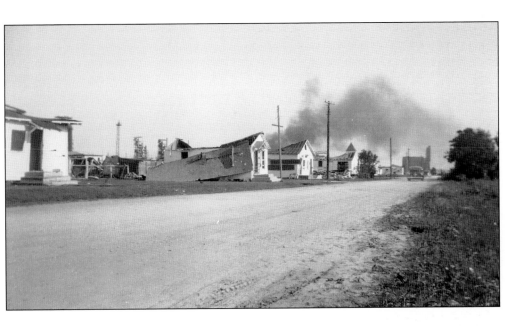

TEXAS CITY DISASTER, 1947. The houses above were very close to the industrial area, and when the *Grand Camp* and the *High Flyer* exploded, most were damaged beyond repair. The fire burned for several days after it was considered safe. The grain elevator seen above, which appears to be at the end of the road, was never used again. The house below was the closest residence to the *Grand Camp* and the home of Lulu Meador, mother of Johnny Mitchell. She was not home during the explosion but a friend was and miraculously survived. The land became Monsanto's front gate.

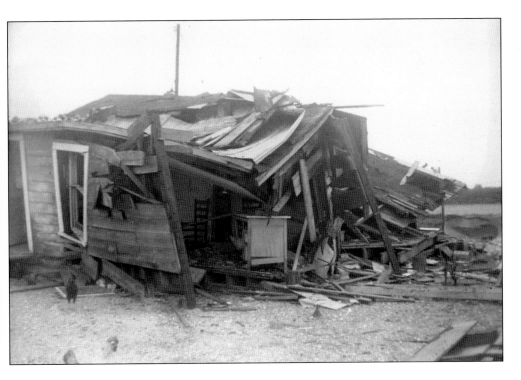

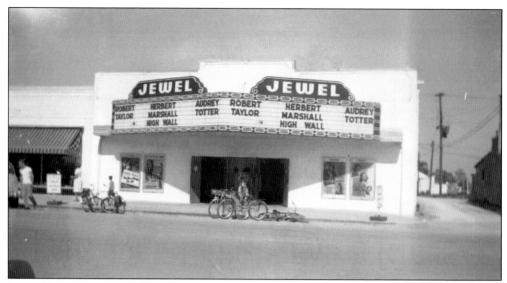

JEWEL THEATRE, 1948. The Jewel Theatre was in Texas City by 1915. It was originally a silent-movie theater when John G. Long purchased it in 1927. In 1929, he wired it for sound. It was still showing movies until the early 1950s. The building still stands at 518 Sixth Street.

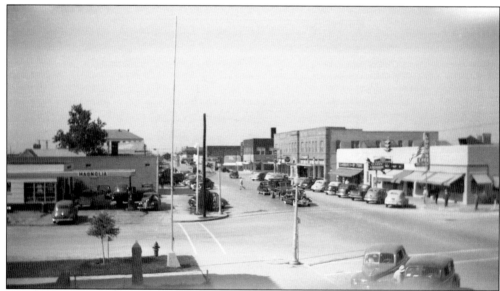

SIXTH STREET, 1948. This photograph was taken from the steps of the old city hall, looking north on Sixth Street. Lucus Café was a popular gathering place, and Cameron's Nickel and Dime was a great place for kids to shop. The Mainland Building, the only three-story structure in town, can be seen on the left. Parades were commonplace on Sixth Street, and pep rallies were common on this corner.

Two

THE BUSINESS DISTRICT

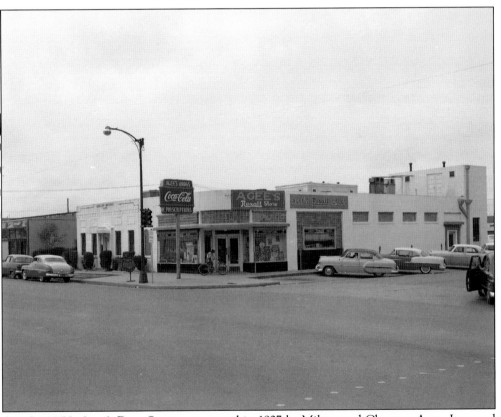

AGEE'S, 1955. Agee's Drug Store was opened in 1927 by Milton and Clarence Agee. It moved to this location at 221 Sixth Street North in 1938. It was still in business in the late 1980s and remained an office for Faust Medical Equipment and Supply, Inc., in the 1990s.

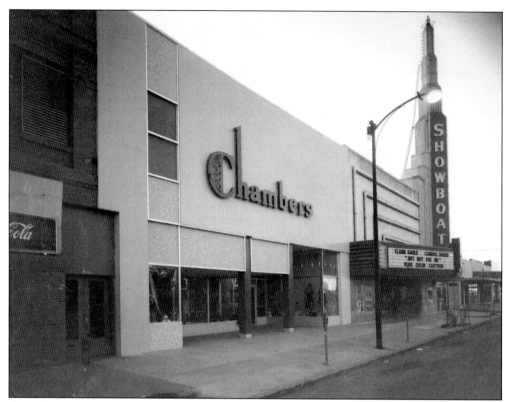

CHAMBERS AND THE SHOWBOAT, 1959. Chambers opened in this location in the late 1940s and was still open in the late 1970s. The original Showboat Theatre opened in 1942, but it was destroyed six months later by fire. The second Showboat was built in 1942, only to be destroyed by a hurricane in 1943. The third Showboat was built in 1944, and was destroyed by the 1947 disaster. The fourth and final Showboat was built in 1949. It closed in the mid-1970s. In spite of a "Save Our Showboat" campaign, it was torn down in 2000 and replaced by the Showboat Pavilion.

DOCTORS' OFFICES, 1956. Dr. Lawrence Rosenblad, Dr. Henry Schmidt, and Dr. Robert Green practiced medicine in the Texas City Clinic at 830 Tenth Avenue North in the 1950s.

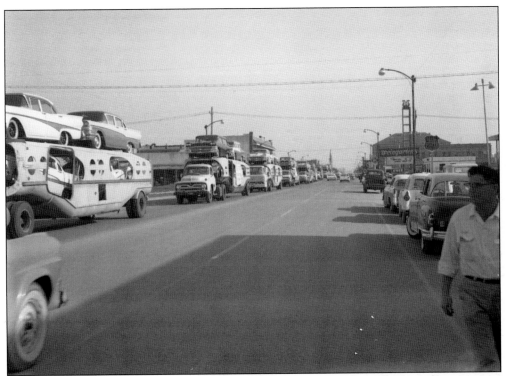

GENE HAMON FORD, 1958. In this 1958 photograph, new Ford automobiles are being delivered to the recently opened Gene Hamon Ford, located at 1031 Sixth Street North (above). New 1959 Ford trucks are lined up in front of the showroom (below). Gene Hamon moved to Palmer Highway in the late 1960s. After 2000, the dealership was sold.

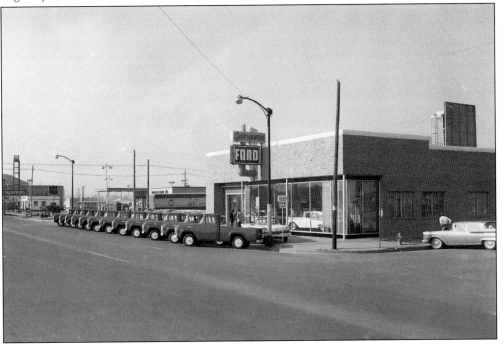

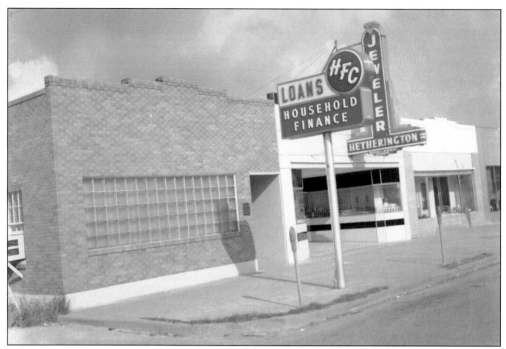

HFC AND HETHERINGTON JEWELERS, C. 1961. The HFC Building contained offices for insurance agents, accountants, and a loan company. Hetherington Jewelers was founded by George and Bertie Mae Hetherington in 1927 and closed by 1988. It soon reopened as Carrell's.

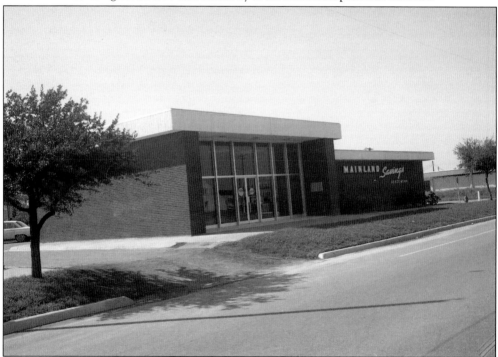

MAINLAND SAVINGS BANK, 1963. Mainland Savings and Loan Association was chartered in 1947, and in 1959, it occupied this building at 1221 Sixth Street North.

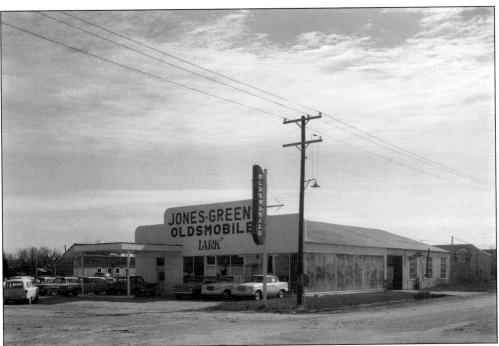

JONES GREEN OLDSMOBILE, 1960. This dealership opened in 1956 on Texas Avenue. In 1959, it moved to this location at 737 Third Avenue North (above and below). Oldsmobiles and Studebaker Larks were sold. It moved to Sixth Street in the late 1960s.

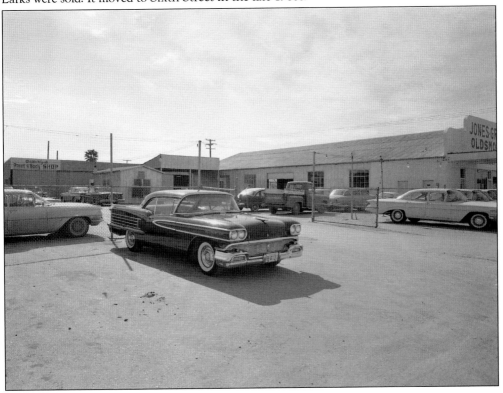

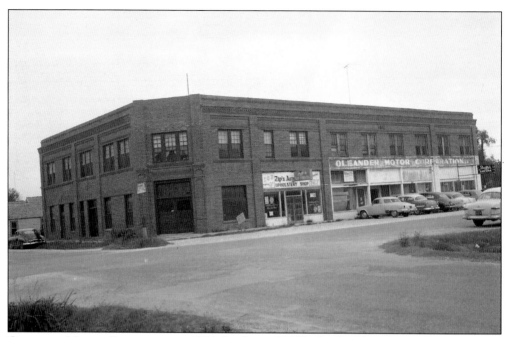

OLEANDER MOTOR CORPORATION, 1954. In the mid-1940s this building, located at 105 Fourth Street North, was the Oleander Ford dealership, which opened in 1934 with six employees. In the late 1940s, Oleander moved to 1031 Sixth Street. Gene Hamon became the Ford dealer at that location in 1958.

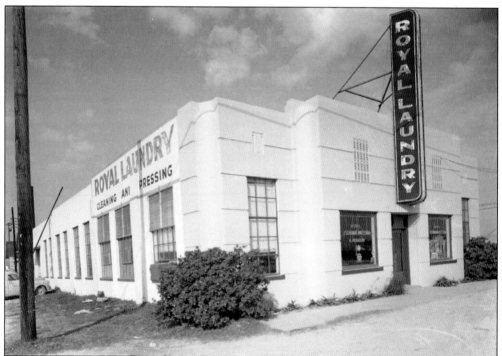

ROYAL LAUNDRY, 1955. Built in 1941 on Texas Avenue as Texas Laundry and Cleaners, Royal Laundry claimed to be Texas City's oldest professional service.

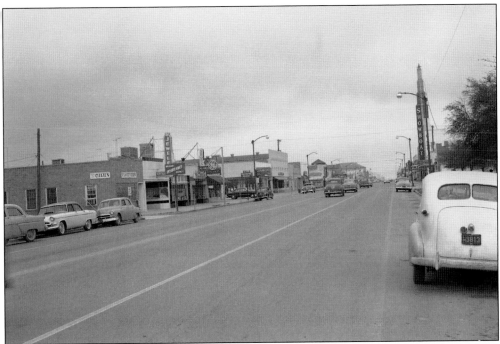

300 Block of Sixth Street, 1955. Some visible businesses that lasted a lifetime on Sixth Street are Hetherington Jewelry, Franklins, J.C. Penney, Peterman's Jewelry, First State Bank, and the Showboat Theatre.

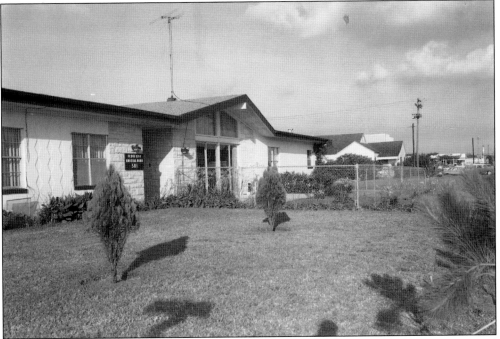

Texas City Nursing Home, 1967. The Texas City Nursing Home opened in 1961 and moved to this location behind Danforth Hospital by 1963. It changed names in the 1970s and closed in the 1990s.

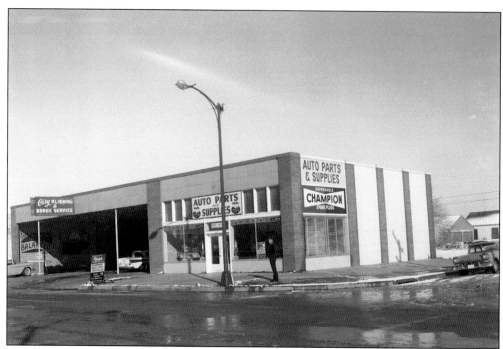

AUTO PARTS AND SUPPLIES AND CITY ALIGNING AND BRAKE SERVICE, 1960. Glen Nutley, owner of Auto Parts and Supplies, is in front of his business at 802 Texas Avenue after the snowstorm of February 1960. As there were no doors, City Aligning and Brake Service appeared to always be open.

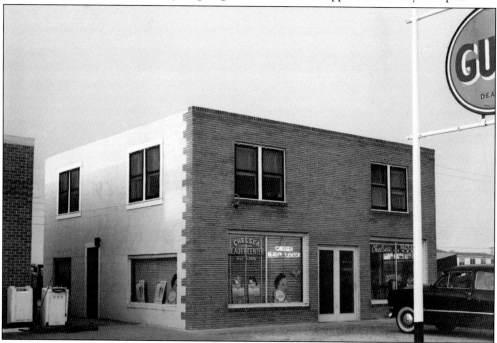

CHELSEA GULF STATION AND CHELSEA BEAUTY CENTER, 1954. This was a combination Gulf service station, beauty center, and liquor store on Texas Avenue. By 1958, only the service station survived. Today, it is La Poblana Taqueria.

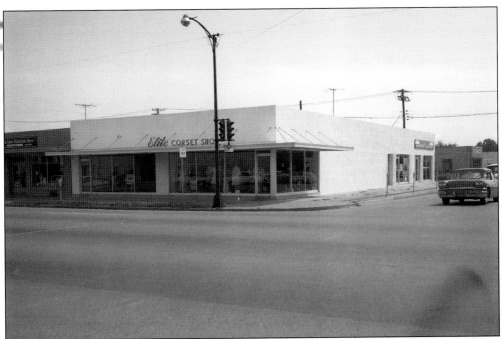

Elite Corset Shop, 1958. Elite Corset Shop occupied several locations on Sixth Street. This location, at 702 Sixth Street North, is where the Grossman Nash building burned in 1953.

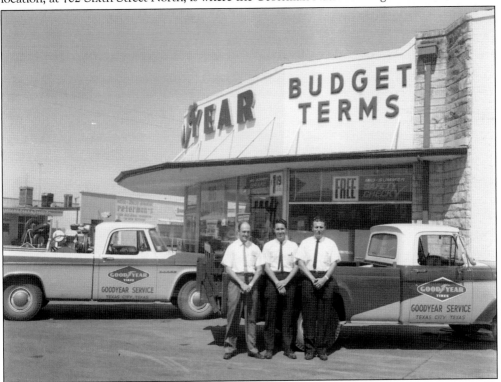

Goodyear, 1964. Goodyear Tires opened in this location in the mid-1950s. In the early 1950s, this was the site of the Bart Welsh Plymouth and DeSoto dealership.

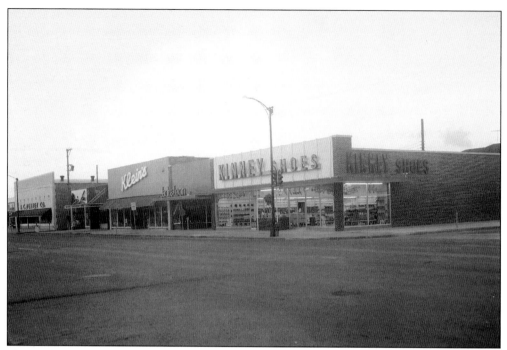

KINNEY SHOES, 1959. In 1959, Kinney Shoes moved from down the street into this new building. The shop vacated by the late 1970s. Other stores in this photograph include Jack and Leon, Klein's, Roger's, Winnie Lee Shop, and J.C. Penney Co.

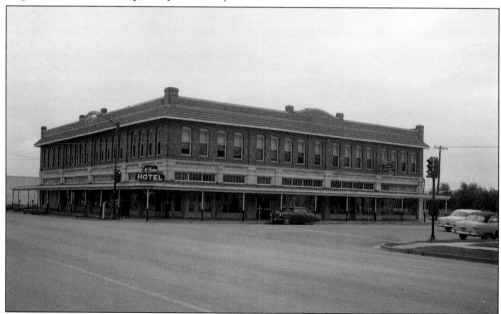

MCILVAINE BUILDING, 1955. The McIlvaine Building was constructed in 1913 at 902 Sixth Street North. In 1940, it was listed as the Speed Hotel, and it housed the Bay Motors Chevrolet and Oldsmobile dealership. By 1943, it was the McIlvaine Hotel, which ceased operations by the early 1960s. In the 1950s, Community Public Services occupied the right corner. Today, the Fork and Spoon restaurant is located in the original hotel lobby.

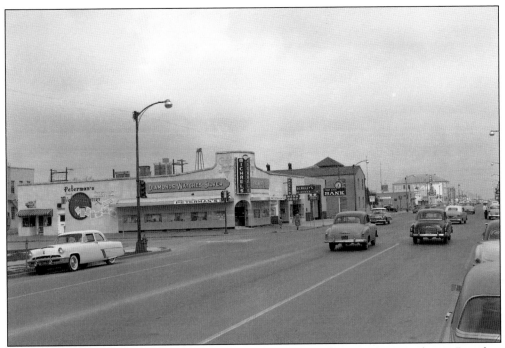

PETERMAN'S JEWELRY, 1955. Michael's was in this building at 501 Sixth Street by 1947, and in 1955, it became Peterman's. By 1969, it became Laufman's Jewelry, and it closed by 1977. It presently holds the offices for the *Post* newspaper.

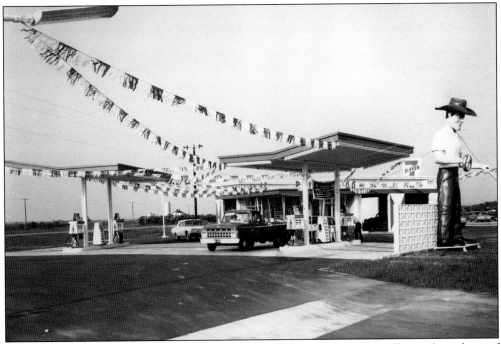

SERVICE STATION ON NORTH LOOP, C. 1966–1967. Full-service stations will soon be a thing of the past, but this Phillips 66, located on Loop 197, is not self-serve. At this time, attendants still checked the oil and tires and washed the windows.

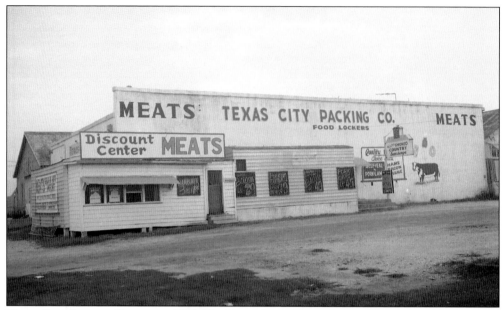

TEXAS CITY PACKING COMPANY, 1955. The Texas City Packing Company was part of the Artesian Ice and Cold Storage Company, which dates back to 1909. Gus' Barbecue was operating here in 1962, before moving to Ninth Street. This building, at 912 Eleventh Avenue North, burned down around 1978.

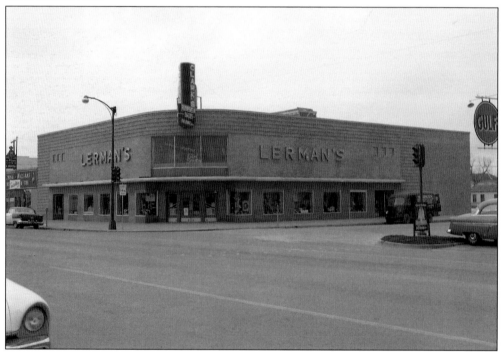

CLARK'S AND LERMAN'S, 1955. Clark's Department Store opened on Texas Avenue in 1924. After the explosion of 1947, this new building opened at 119 Sixth Street North. The owner, Charlie Lerman, changed the name to Lerman's. It later became Wiener's and continued in business until the mid-1970s. In the 1990s, it was a men's center.

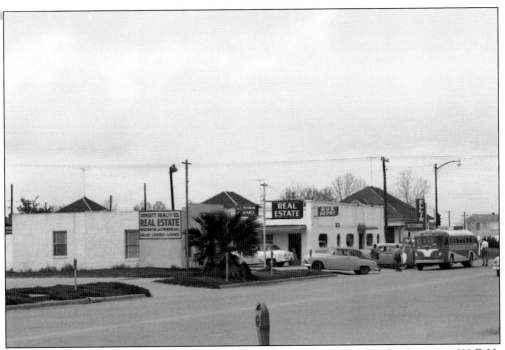

Ellis' Restaurant and Bus Station, 1955. Ellis' Restaurant opened at this location, 629 Fifth Avenue North, in the late 1940s. It was also the bus depot for Texas Bus Lines. By the mid-1960s, it became Mae's Restaurant, and the bus depot moved to the 100 block of Sixth Street.

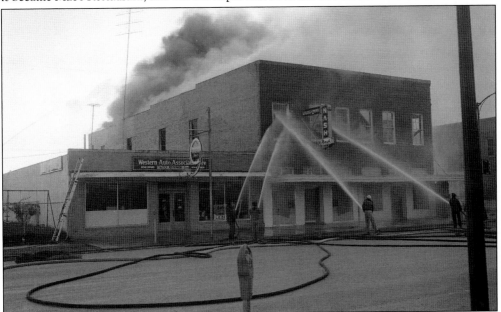

Grossman Nash Fire and Western Auto Store, 1953. The Grossman Nash automotive repair building burned in 1953. Miraculously, the Western Auto Store next door was spared. Western Auto was in a building one block south through the 1940s and stayed there until around 1950 when it moved into this building and was operated until 1981. Mayor L.A. Robinson was an early owner.

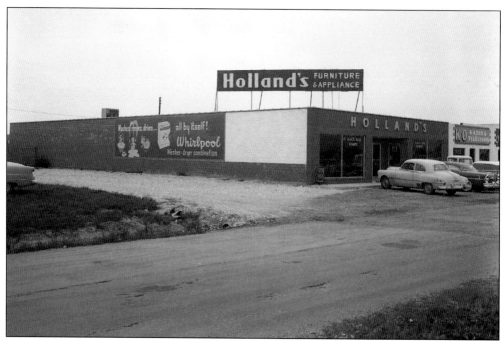

HOLLAND'S FURNITURE, 1955. This business served Texas City from 1948 until the late 1960s. It was owned by Walter Holland, mayor of Texas City from 1962 to 1964.

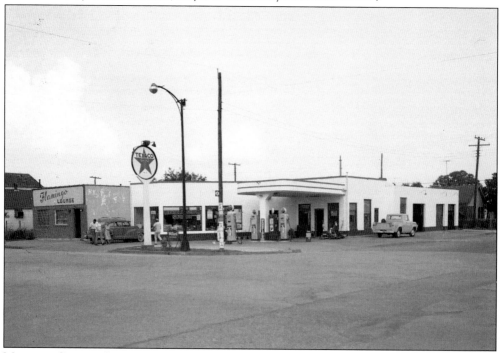

MITCHELL SERVICE STATION, 1958. Johnny Mitchell opened this Texaco station, located at 431 Texas Avenue, in 1941. In the late 1950s, he began to work on lawn mowers. By 1965, it was one of the largest lawn mower shops in the county. He sold this building in 1975 and continued to work on mowers at his home until his death in 1997.

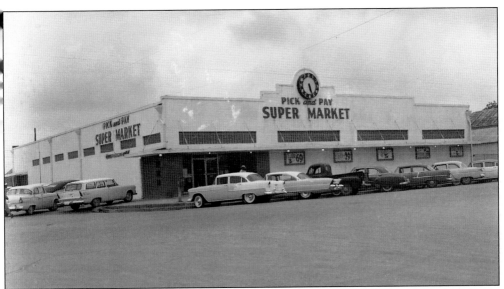

PICK AND PAY, 1955. This business, owned by Jimmy, Herbert, and Bernard Levin, began operation as a small store in 1933. It was located one block east of this building. In 1945, the Levin brothers moved to this large building at 430 Texas Avenue, and the business stayed there until the late 1960s.

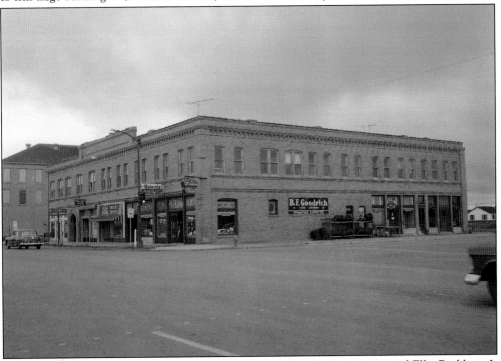

STANSFIELD'S SUPPLY, 1955. Built by 1913, this was called the Livingston and Ellis Building. It housed the Harper Hotel initially, the Livingston Hotel in the 1920s, and the Avalon Hotel during World War II. The locations of several business are included in this photograph, the largest being Stansfield's Supply. Woody and Charlie Stansfield were in business in 1937, but they opened Stansfield's Supply after World War II. They moved into this building in 1950, moved to Ninth Street in 1980, and closed in the late 1980s. This building now houses Mainland Pharmacy.

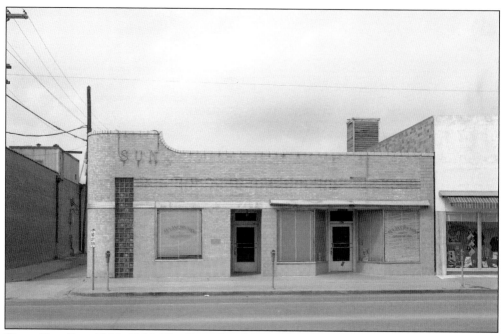

TEXAS CITY SUN, 1954, 1956. The *Texas City Sun* was founded in 1912. It moved to the building above in 1941 and to the building below, located at 624 Fourth Avenue North, in the mid-1950s. Below, the man protesting is wearing a sign that reads, "Fired Policeman for Exercising my American Privilege by Supporting Candidate of My Choice."

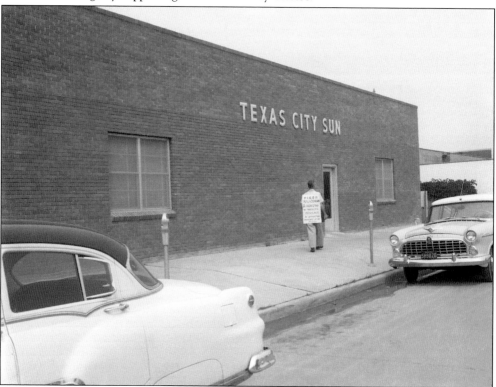

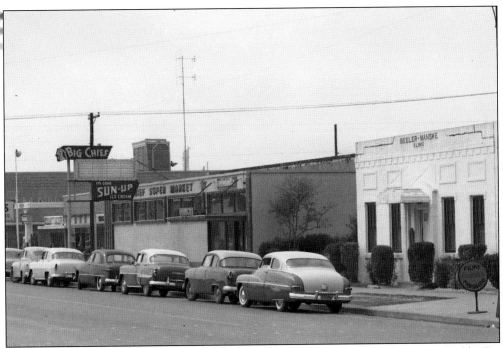

BEELER-MANSKE CLINIC AND BIG CHIEF SUPER MARKET, 1955. The clinic was opened by Dr. George Beeler and Dr. W.T. Manske. Big Chief opened in October 1951 and was still operating in the late 1970s. Little Chief Mini Markets were a spin-off in the 1960s.

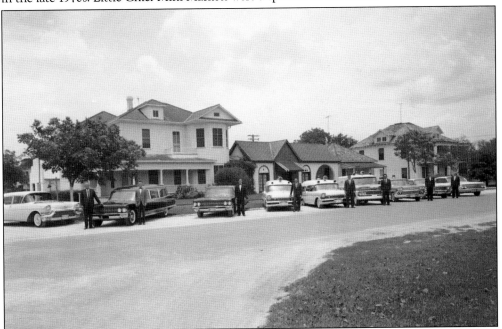

EMKEN-LINTON FUNERAL HOME, C. 1961. This photograph shows Fred Linton (far left) and Emken Linton (next to Fred) in front of Emken-Linton Funeral Home, along with other employees and vehicles. This is the original building in which H.B. Emken began the funeral home business in 1911. It was used until a state-of-the-art facility was dedicated in December 1986.

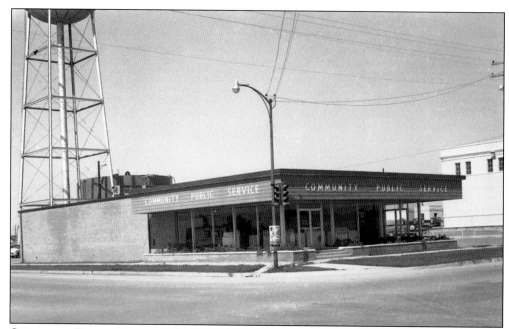

COMMUNITY PUBLIC SERVICE, 1954. In 1936, Community Public Service was the electricity service provider for Texas City, serving 800 customers. In 1954, a new office building was constructed for customer service (above). Reddy-Kilowatt stands tall on the operations and maintenance warehouse (below). Today, these buildings are occupied by the Texas–New Mexico Power Company.

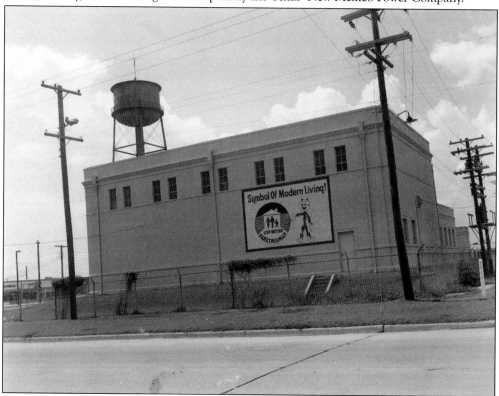

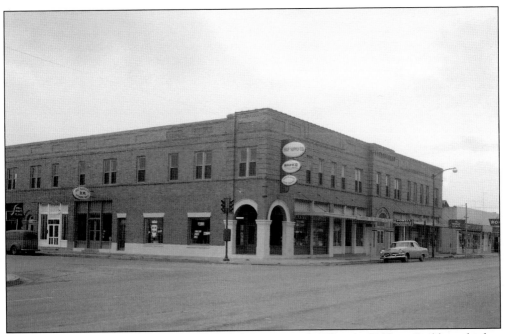

GULF STATES BUILDING, 1955. Built before the Hurricane of 1915 as the Baldwin Building, this has been the location of dozens of businesses in its century of existence. In the 1940s, it was the Plaza Hotel and Western Auto Associate Store, and in the 1960s, Mainland Pharmacy operated in the left corner. "Gulf States Building" is stenciled on the center glass, giving the building its name.

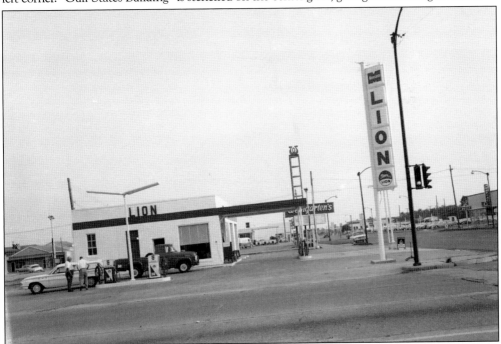

LION SERVICE STATION, 1961. In the 1960s, Monsanto marketed Lion gasoline. This Lion Service Station belonged to Bart Welsh, a local businessman. Mahaffey Pontiac can be seen at the right, and Weingarten's is at the left.

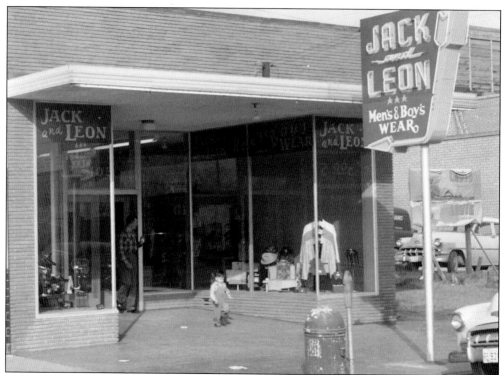

Jack and Leon Men's and Boy's Wear, 1957, 1959. Jack Klotzman and Leon Kauftheil opened Jack and Leon Men's and Boy's Wear in the mid-1950s. Their store, which was located between the Texas Theatre and Lerman's (above), is pictured. Below, the business moves to a new location on Sixth Street, and Mayor Jack Godard (far right) is present for the grand opening.

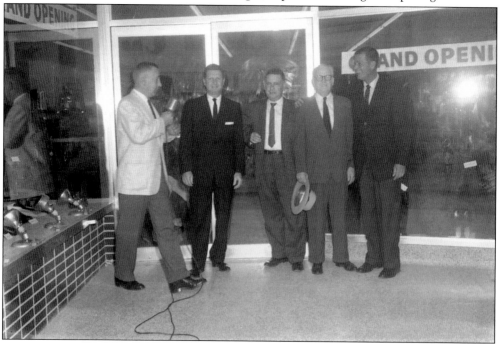

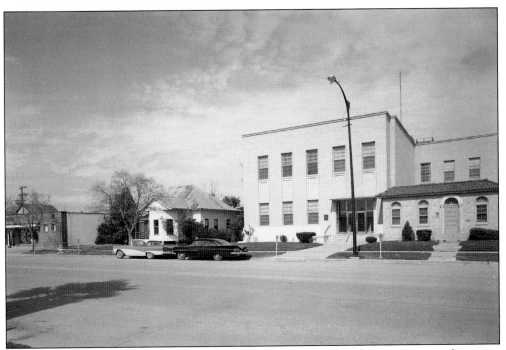

MONTGOMERY HOUSE AND THE PHONE COMPANY, C. 1959. The Olga Montgomery house sat between Cook's Paint and the phone company. The phone company bought the land, removed the home, and increased the size of its building.

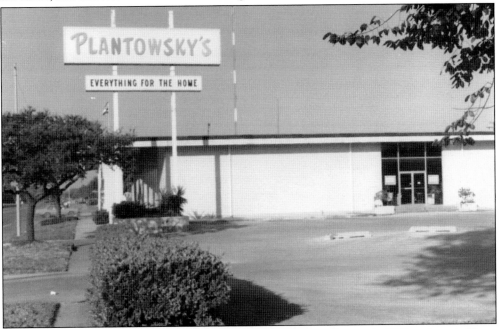

PLANTOWSKY'S, 1975. Plantowsky's began business in Galveston County in 1925 and was in Texas City by 1941. It moved into this building at 832 Fifth Avenue North in 1964 and remained through the 1970s. Other furniture stores occupied the building, with Sussan Furniture being the last. When Sussan moved in 1997, the building housed a private school and later a funeral home.

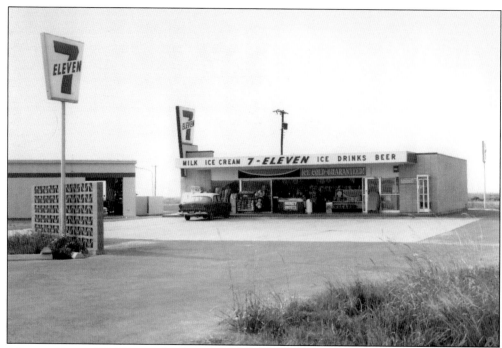

7-ELEVEN STORE, 1966. Located on Loop 197, this 7-Eleven is typical of those that were in Texas City in the 1950s and 1960s. There was no air conditioner, and the front door was wide open. Gasoline was not sold yet but everything else was. The company left this part of Texas in the 1980s.

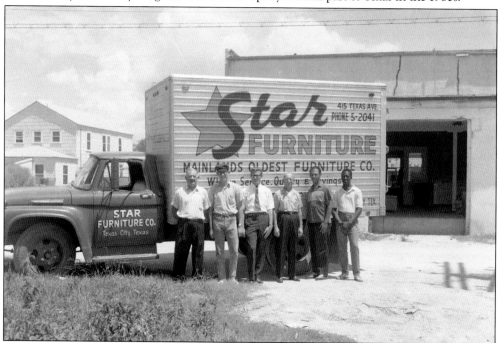

STAR FURNITURE, C. 1964. Joe Lerner (far left), pictured with employees, opened Star Furniture in 1930 and moved to its location at 415 Texas Avenue by 1947. The business did not close until 1998. The building is still full of merchandise.

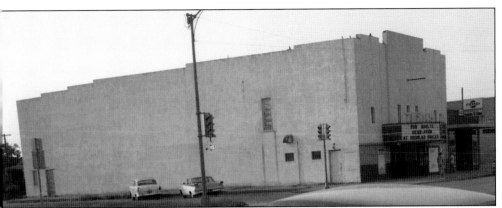

TEXAS THEATRE, 1966. This theater was opened by Johnny Long in the late 1930s. In 1941, it advertised that a complete floor show and vaudeville was being brought to Texas City and would perform each Sunday and Monday. A church met there in the 1970s, and the building burned down in 1977.

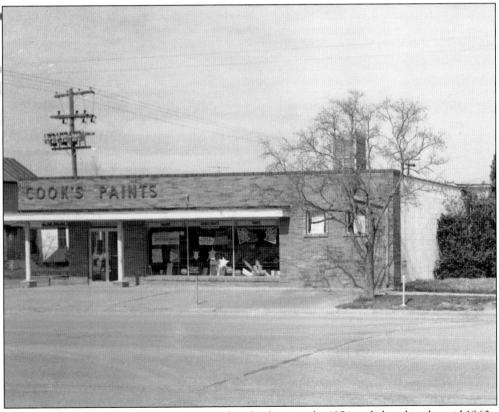

COOK'S PAINT, C. 1959. Cook's Paint opened at this location by 1954 and closed in the mid-1960s. This building is now home to Bass Taxidermy, Inc.

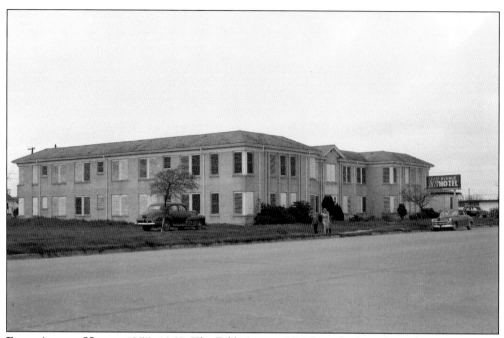

FIFTH AVENUE HOTEL, 1955, 1963. The Fifth Avenue Hotel was built in the early 1950s on Fifth Avenue. It advertised private baths and telephones and air-conditioned rooms. By 1963, it ceased being a hotel and became Fifth Avenue Home for Nursing Care, which was closed by the state in 1994. The building was subsequently demolished.

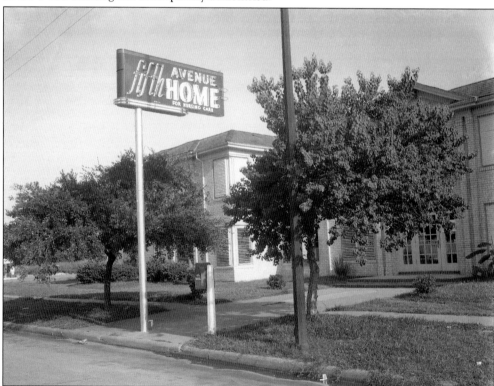

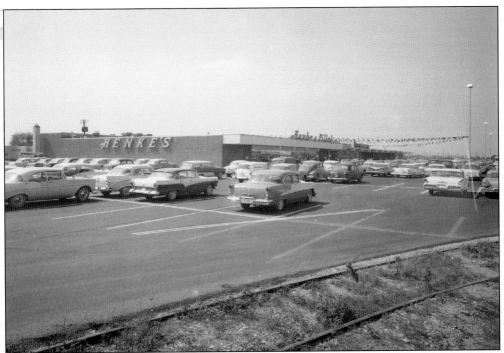

HARBOR VILLAGE SHOPPING CENTER, 1959, 1962. Harbor Village Shopping Center opened in 1959. The photograph above shows Henke & Pillot Grocery Store, Beall's Department Store, and Mading's Drug Store. At least six other stores are being built. The tracks in the foreground date back to 1911, when the Tenth Avenue Train Depot sat on this lot. Below, a completed shopping center is pictured, with Whites to the far right. The shopping center was demolished, and the Rankin L. Dewalt Criminal Justice Center now occupies this location.

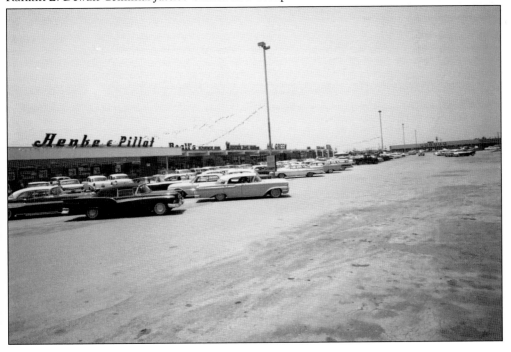

J.C. Penney Co., 1955. J.C. Penney opened at 409 Sixth Street in 1948. After 42 years of operation, it closed in 1990. It reopened the next year in the new Mall of the Mainland. Many locals saw this as the end of downtown. The city acquired the building in 1992, and by 1994, it had become the Texas City Museum.

Mae's Restaurant, 1967. Mae's Restaurant, located at 629 Fifth Avenue North, previously Ellis' Restaurant, is having a makeover in this photograph. In the mid-1960s, a smorgasbord ("all you can eat") attracted considerable attention.

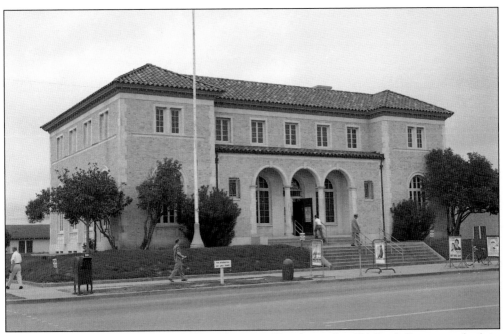

Post Office on Sixth Street, c. 1960. The post office, located at 301 Sixth Street, was built in 1932 at a cost of $80,000. It was also home for the armed forces recruiters. It became a substation, named Meskill Station after a retired postmaster, when a new post office was built on Fourteenth Street in 1962. It is now part of the City of Texas City Public Works Department.

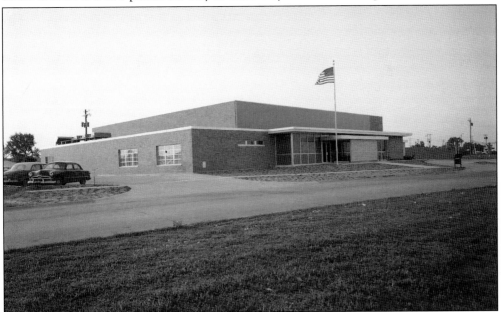

New Post Office, 1962. The new post office was officially dedicated on May 1,1962, with the Texas City High School band playing and J. Edward Day, the postmaster general, telling the crowd that stamps would soon go from 4¢ to 5¢. Expecting the large crowd, the police closed off Fourteenth Street between Ninth Avenue and Thirteenth Avenue North. The post office has again moved, this time to the Tradewind Shopping Center.

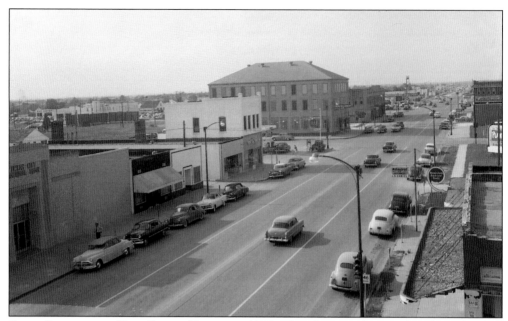

SIXTH STREET FROM GULF STATES BUILDING, 1953. This photograph was taken from the Gulf States Building, looking north on Sixth Street. On the left, the Texas City National Bank is seen before it was remodeled. Next is Tot-To-Teen, which was Texas City Drugs in 1915. The three-story Mainland Building is visible in the middle of the photograph, and the McIlvaine Building can be seen rising to the far right.

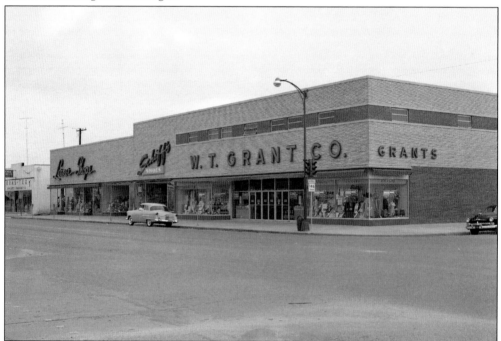

W.T. GRANT CO., 1955. W.T. Grant opened in Texas City in 1954. It closed in the early 1970s, just prior to the second-biggest bankruptcy in US history at the time. The building still stands on Sixth Street, and the W.T. Grant Foundation is still strong.

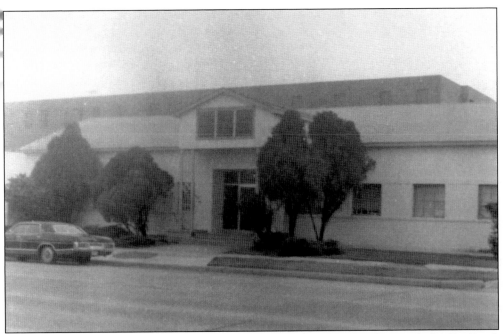

DANFORTH MEMORIAL HOSPITAL, C. 1974. Danforth Memorial Hospital, named after Dr. Frank Danforth, began as Danforth Clinic in 1937. It included six beds for minor surgery and the delivery of babies. Prior to the 1940s, many Texas City babies were delivered at home. The hospital began operating around 1946 and continued to serve Texas City into the 1990s.

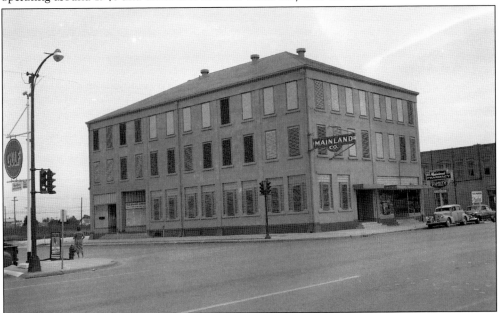

MAINLAND BUILDING, 1955. The only three-story structure in Texas City, the Mainland Building was originally called the Board of Trade Building. It was built in 1895 and housed many businesses. The Mainland Pharmacy occupied the first floor to the right, and it continues to operate in the building visible on the right. The Mainland Building is now home for many Texas City residents in the form of loft apartments.

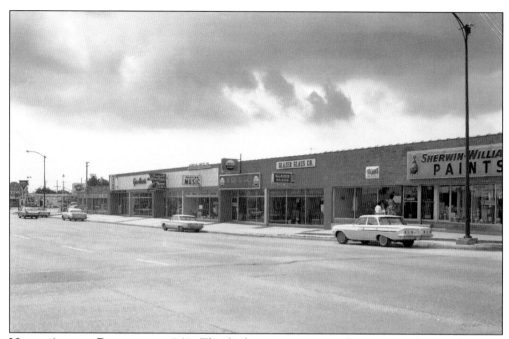

NINTH AVENUE BUSINESSES, 1963. This little strip center ran down Ninth Avenue between Ninth Street and Tenth Street. The businesses were Sherwin-Williams Paints, Parkman's Fashions, Glazer Glass Company, Sam Hawkins Sewing Machine Sales, Parker Music Company, Feazell Advertising, Goodbar's, Montgomery Ward, and Shipley Donuts.

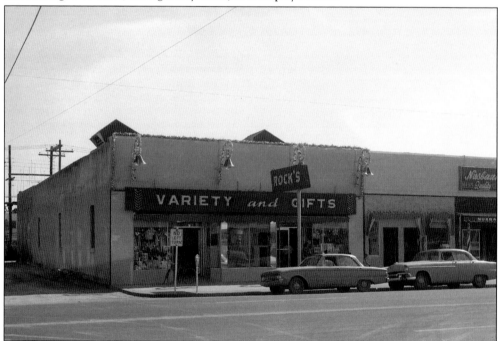

ROCK'S VARIETY AND GIFTS, C. 1963. Rock's (previously Cameron's) opened in the early 1950s. A great place for a kid with a couple of dimes, Rock's had a vast toy selection, but it was difficult to shop with the eagle-eye employees. The building burned in 1975.

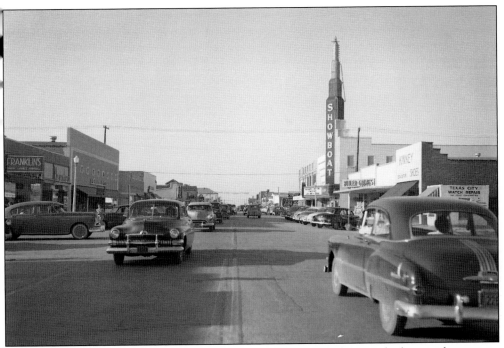

400 Block of Sixth Street, 1955. The streets were filled with shoppers looking in department stores, clothing stores, jewelry stores, shoe stores, and nickel-and-dime stores. The traffic was a little congested for that era.

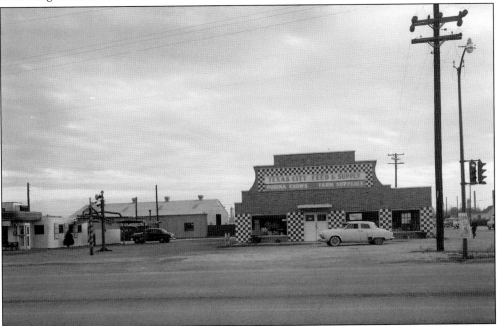

Texas City Feed Store and Dupree's Drive-In, 1955. By 1953, Texas City Feed and Supply had moved to this location at the corner of Texas Avenue and Twenty-first Street. It is still operating, with few visible exterior changes. Dupree's, far left, a traditional drive-in with carhops, opened in the early 1950s and closed in the late 1960s.

WELCH BROTHERS' CHEVROLET, 1957. This dealership opened in Texas City in 1955. The family had been in the car business since 1923 in San Benito, Texas. A line of 1957 Chevrolets are waiting for customers in this photograph. Welch Brothers' closed in the early 1980s.

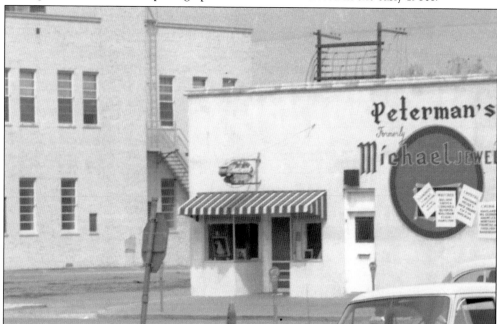

CHADWICK'S STUDIO, 1955. Chadwick's occupied this obscure building at 610 Fifth Avenue North during the 1950s and 1960s. In the 1970s, the studio was moved to Sixth Street, and the building was destroyed by fire in 1975. Without delay, Jack Gibby, who had worked for Chadwick's since 1950, opened Gibby's Photography and was still photographing Texas City in the 21st century.

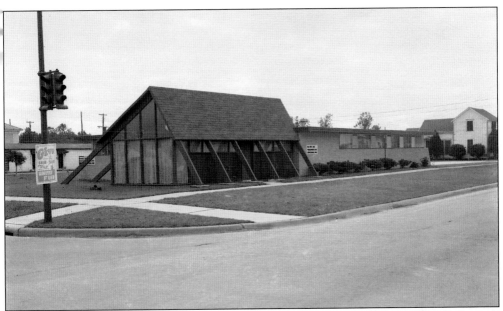

DOCTORS' OFFICES, C. 1960. Doctors H.G. Tree, W.M. Gambrell, and J.D. McConnell practiced medicine and dentistry in this building, located at 831 Fifth Avenue North, in the 1950s and 1960s.

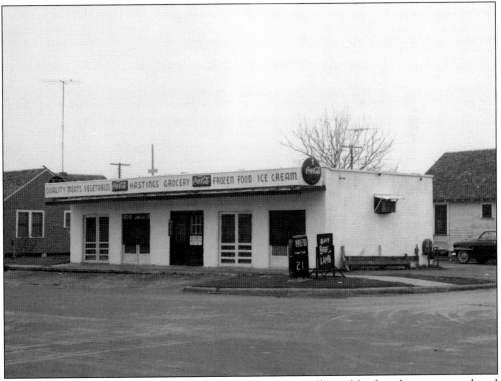

HASTINGS' GROCERY, 1955. Hastings' Grocery was a small neighborhood store, owned and operated by V.F. Hastings, from the early 1950s to the mid-1960s. It was located at 802 Fifth Avenue North.

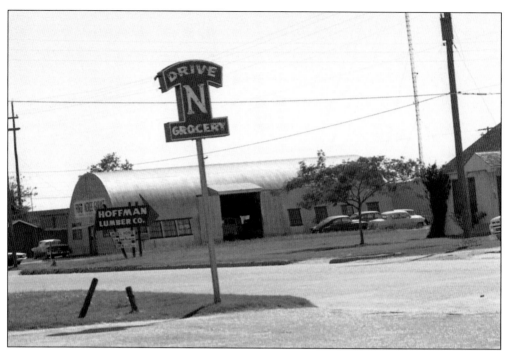

FORD ACREE GARAGE, 1963. Ford Acree opened his automobile repair shop in 1938 on Third Street North. He occupied this Quonset hut at 519 Ninth Street North in 1948 and his business operated there through the 1960s.

HOFFMAN LUMBER COMPANY, 1963. Roy Hoffman opened his lumber company behind Ford Acree Garage by the early 1950s. It has changed ownership twice, but it is still operating at the same location, 915 Sixth Avenue.

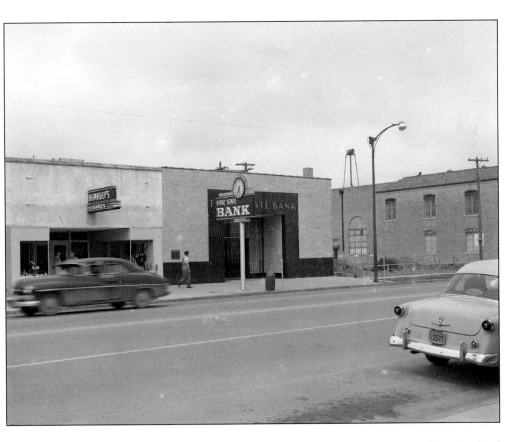

First State Bank, 1955, 1958. First State Bank, later Mainland Bank and Trust, then Mainland Bank, opened in September 1945 in the 500 block of Sixth Street. It remained at that location until the late 1970s, when it was moved to the corner of Palmer Highway and Twenty-ninth Street. The building is now a private residence.

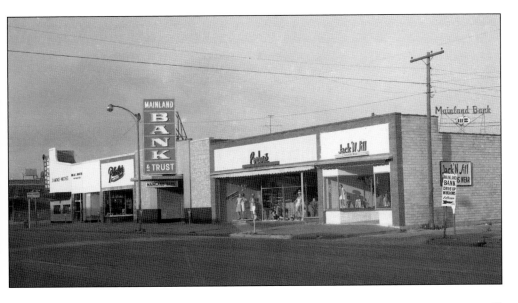

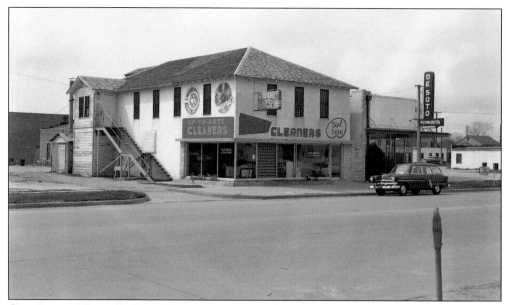

ODD FELLOW HALL, DESOTO DEALERSHIP, 1955. The International Order of Odd Fellows met in this building at 609 Fifth Avenue prior to the explosion of 1947 and continued to meet there until after 2000. The order got its name because it was deemed odd in 18th-century England. This was due to the fact that it was organized for the purpose of helping others in need without recognition. Also in the photograph are the Bart Welsh DeSoto/Plymouth Dealership and Up-To-Date Cleaners.

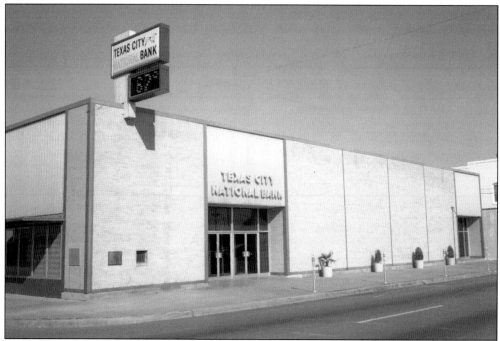

TEXAS CITY NATIONAL BANK, 1966. Texas City National Bank was established in 1907. This building, located in the 700 block of Sixth Street, was constructed and occupied in 1939. It became Texas City Bank and then Merchant's Bank and moved out of this building in the fall of 1997.

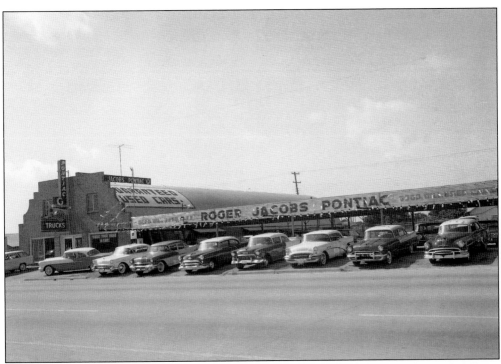

ROGER JACOBS PONTIAC, 1959. Roger Jacobs Pontiac operated through the 1950s at 1219 Texas Avenue. By 1960, only the used car lot survived. It stayed in business through the 1970s.

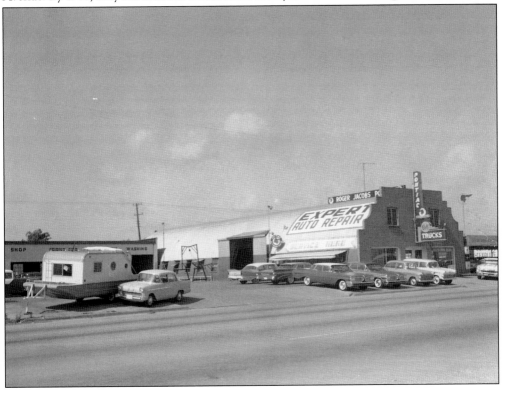

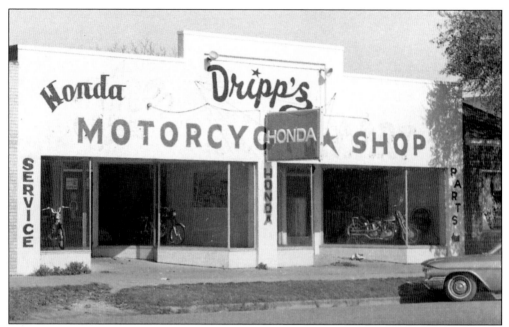

DRIPP'S HONDA, C. 1970. Fred Dripps opened Dripp's Harley-Davidson Motorcycle Shop in 1961, and around 1965, he became a Honda dealer. In 1977, he advertised that he had served Texas City for 35 years, so he must have been working behind the scenes before opening his shop. He operated his store with only a couple of employees, unlike the mega shops of today, and closed in the early 1980s.

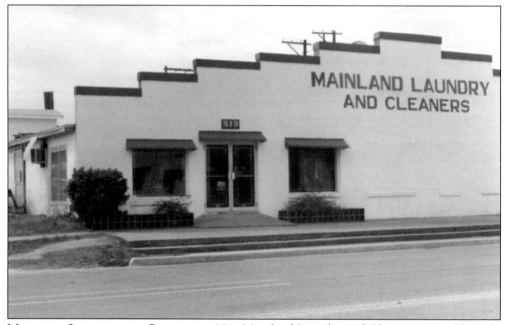

MAINLAND LAUNDRY AND CLEANERS, 1970. Mainland Laundry and Cleaners, started by A.B. Waggoner, has been serving Texas City since 1928. In 1964, it advertised that it used chlorine-free well water for cleaner, whiter laundry. It was still operating in this building until before 2000. The location is now a parking lot for the Showboat Pavilion.

Three

THE PEOPLE

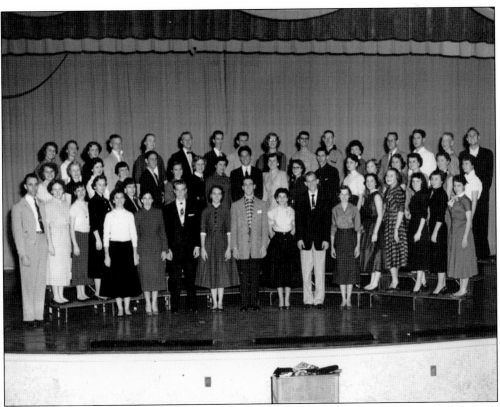

JOHN C. MARTIN, C. 1955. For 46 years, John Martin (far left) was a positive influence to thousands of students at Texas City Independent School District (ISD). He began teaching at Danforth Elementary, then went on to Texas City Junior High, and then Texas City High School. His unselfish dedication was bestowed on both his students and the community. He retired as head of the speech and drama department, and he died in 1996.

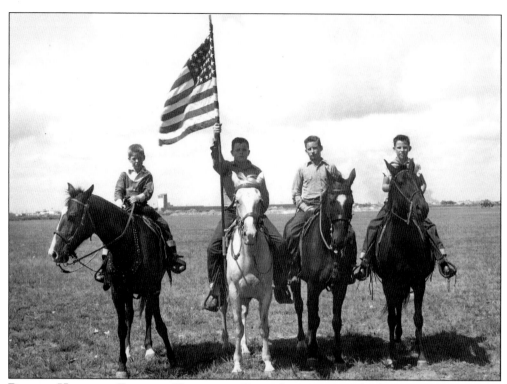

Boys on Horses in Front of Tradewind Drive-In, c. 1952. The boys in this early-1950s photograph appear to be in the country. In the next decade, Moore Memorial Library will stand approximately where they are riding, and the new Texas City High School will be built directly behind them. A few years later, the Tradewind Drive-In, which opened in August of 1951, will be replaced by the Tradewind Plaza Shopping Center.

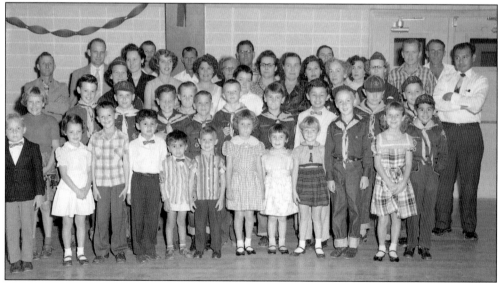

Heights Elementary Cub Scouts, 1956. Heights Elementary School was opened in 1938 at 301 Logan Avenue and was named for the surrounding neighborhood in which it was located. Above, Cub Scouts, leaders, and parents are at a meeting in the gymnasium, which still stands.

KIDS AT PARK BEHIND PHONE COMPANY, C. 1954. This was the park behind the phone company and the old city hall. It consisted of swings and seesaws, but those who lived around the city had nothing else. It became a parking lot by the late 1950s. This is most likely a church group.

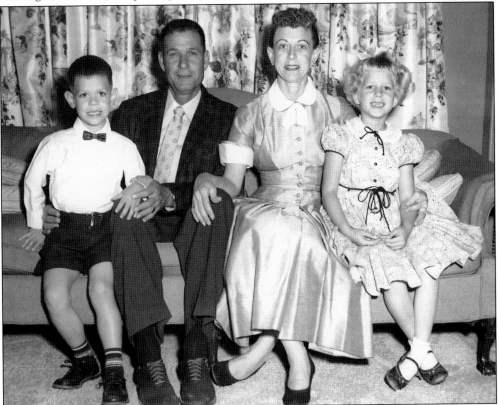

MAYOR GODARD AND FAMILY, 1956. Jack Godard served as mayor of Texas City from 1956 to 1960 and returned as city commissioner from 1962 to 1964. He was known for his honesty and integrity. During World War II, he served as a naval officer in the European and African theaters.

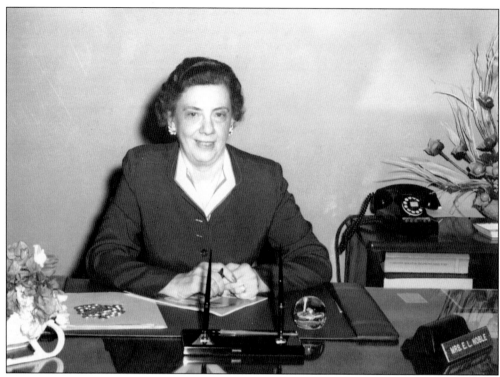

MRS. E.L. NOBLE, C. 1962. Mrs. Earl. L. Noble became chairman of the board of directors of the Texas City National Bank. At that time, she was one of the few women in the nation to hold such a responsible position in banking circles.

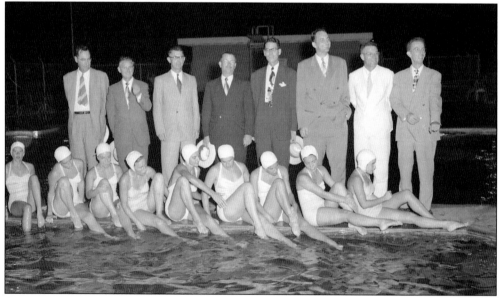

SWIMMING POOL OPENING, 1951. The municipal swimming pool opened in 1951. The opening included the Corkettes from Houston's Shamrock Hilton Hotel and an old-fashioned swimsuit contest. Mayor Lee Robinson is the third from the left. It was a segregated pool; the pool for nonwhites was located at 311 Ninth Street South.

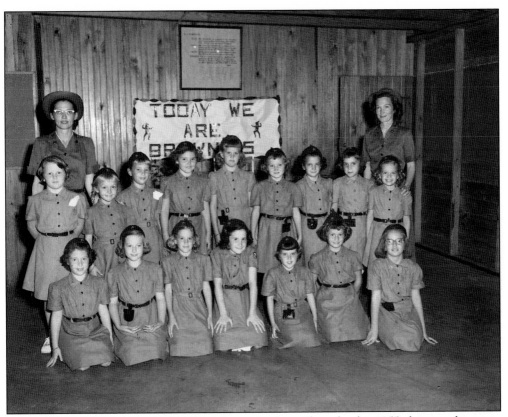

TODAY WE ARE BROWNIES, 1955. This troop poses in uniform for this 1955 photograph.

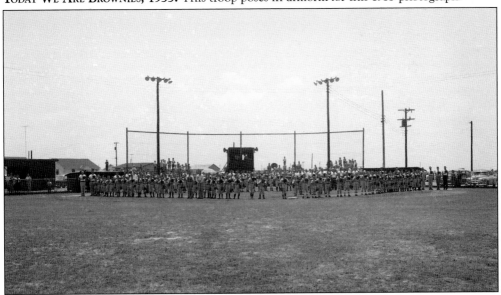

BASEBALL PLAYERS AT ROBINSON STADIUM, C. 1953. Robinson Stadium was named after Mayor Lee Robinson. Hundreds of games have been played on these grounds since it was constructed in the early 1950s. It is a place of thousands of good memories. Players, coaches, umpires, families, and friends are shown enjoying America's pastime: baseball.

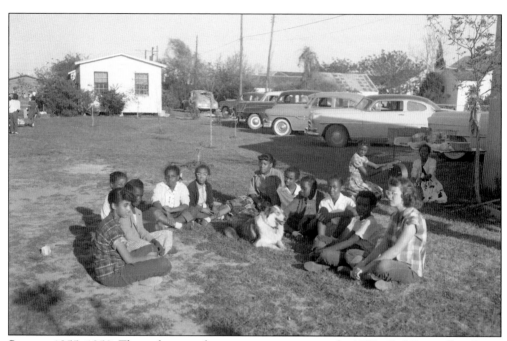

SCOUTS, 1955, 1958. These photographs portray segregation in the 1950s. Girl Scouts Day Camp was held at the Girl Scout Little House on Fifteenth Avenue, and the Boy Scouts from both Texas City and La Marque met in a different location. At that time, there were separate troops for African American youth.

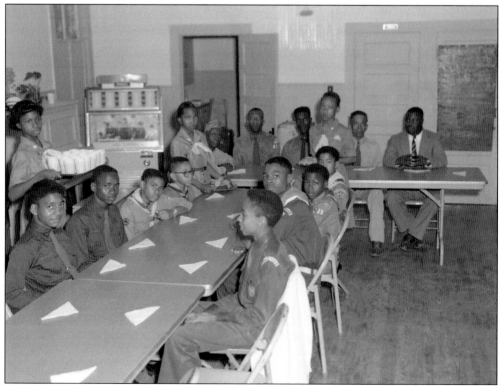

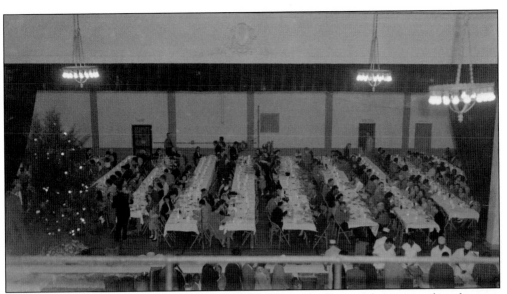

CHRISTMAS DINNER AT OLD CITY HALL, C. 1950. Christmas dinner is being served on the stage in the old city hall in the early 1950s. It appears that everyone is welcome, although some on the right are separate—but equal.

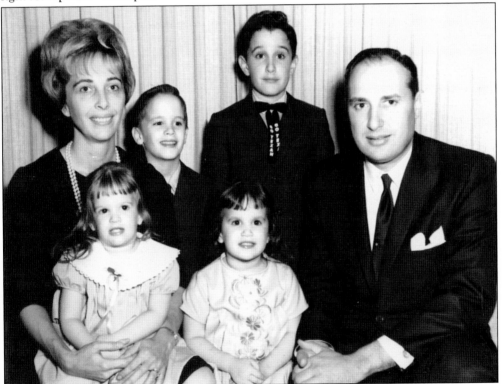

JUDGE PETE LAVALLE AND FAMILY, C. 1963. Pete LaValle resigned his position in the state legislature to become county judge in 1961. After experiencing Hurricane Carla first hand, he was instrumental in the building of the new seawall levee. He served until 1967 when Ray Holbrook became the new county judge.

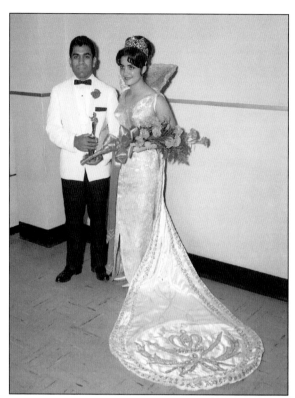

LULAC Queen, 1964. The League of United Latin American Citizens (LULAC) hosted a LULAC queen. At left, she is standing with her trophy and escort, and below, with her proud family.

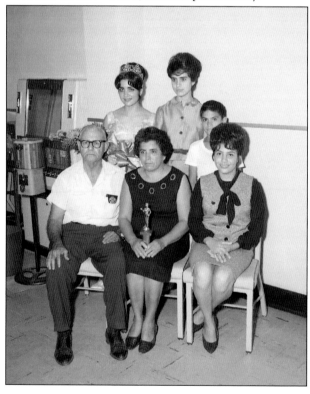

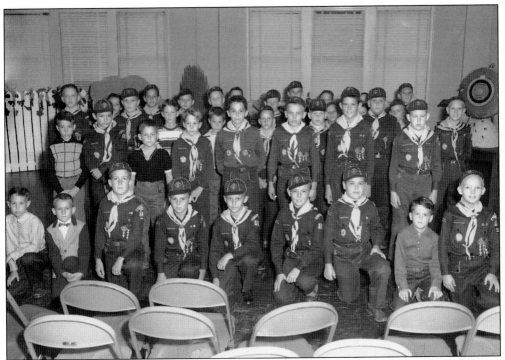

First Methodist Cub Scouts, 1955. This large troop is being sponsored by the First Methodist Church. The awards on their uniforms tell of active leaders and parents and dedicated boys.

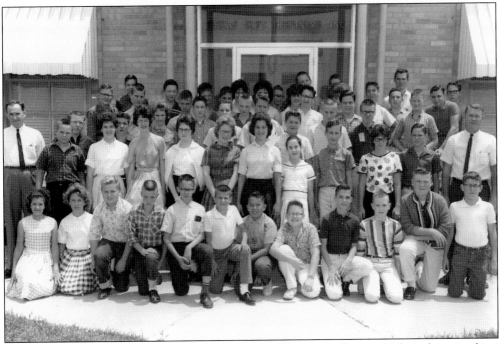

Students Visiting Texas City Refinery, c. 1962. This group of junior high students is taking a field trip to Texas City Refinery. Field trips were not uncommon, and they were a good way to see what some parents did for a living.

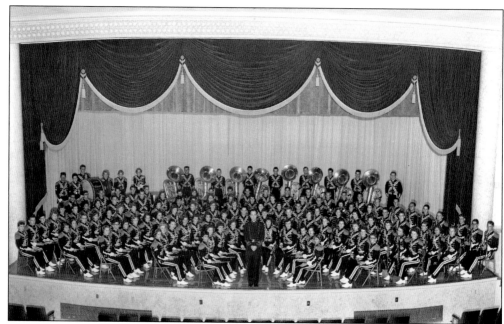

Texas City High School Band and Robert Renfroe, 1957. Robert Renfroe, pictured center stage, came to Texas City as the junior high band director and high school marching director three months after the Texas City disaster. He was 19 years old and 15 hours short of graduating from Sam Houston State Teachers College. He was able to complete his degree by correspondence and summer sessions, and he remained at Texas City for 36 years. His influence and accomplishments are immeasurable.

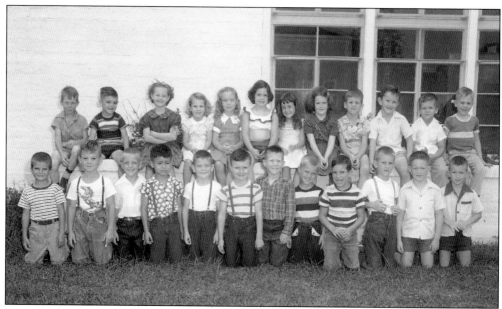

First Presbyterian Church Kindergarten, 1952. This church hosted a private kindergarten before it became part of the state curriculum. This photograph shows the First Presbyterian Church kindergarten class of 1952. Most of these five year old students were still around and graduated together 12 years and seven months later.

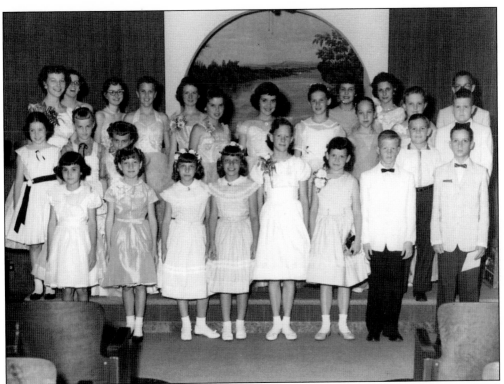

MARTIN PIANO STUDENTS, c. 1960. The piano students of Mrs. G. Allene Martin are pictured after a recital at Calvary Baptist Church. Taking piano lessons was popular during this time when individual achievement was stressed.

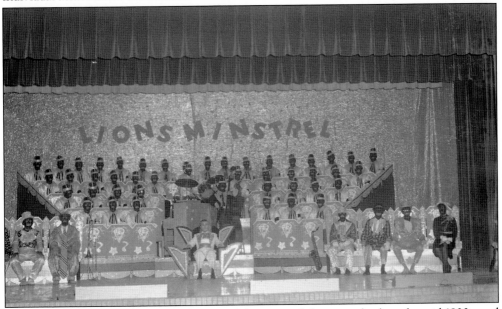

LIONS CLUB MINSTREL, 1956. The history of the minstrel show goes back to the mid-1800s, and it survived longer than it should have. This image of the Texas City Lions Club was taken more than five decades ago.

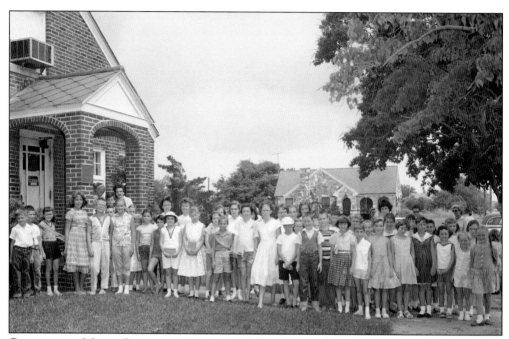

Children at Moore Library, 1959. In 1948, the city purchased this 1.5-story home (above) to be used as its first dedicated library. Previously, the library was located in the old city hall. Summer vacation had just started, and the kids upstairs (below) have their books. The library was named after Col. H.B. and Helen Moore. A much larger library was built on Ninth Avenue in the mid-1960s.

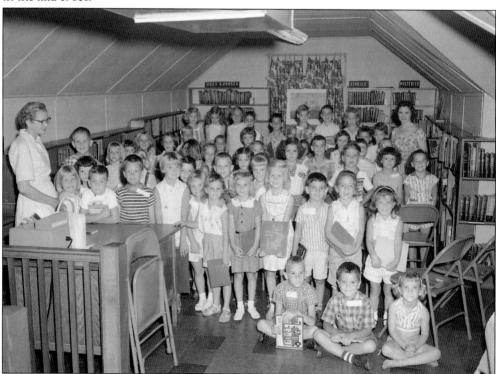

MAYOR LOWRY, C. 1966. Mayor Emmett Lowry was the mayor of Texas City for 25 years. He was a Texas City native, leaving only for college and military service during World War II. Lowry was well loved and respected by the community. The people were devastated by his untimely death in 1989 while he was still in office.

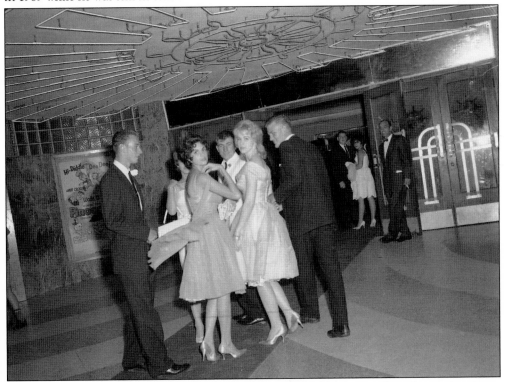

SENIOR NIGHT ON THE TOWN, 1962. The senior class of 1962 is being given the red carpet treatment by the Evening Lions Club and the Kiwanis Club. It is graduation night, and the location is the Showboat Theatre. After the movie, the new graduates will go to the Carl Nessler Civic Center for dinner and to dance.

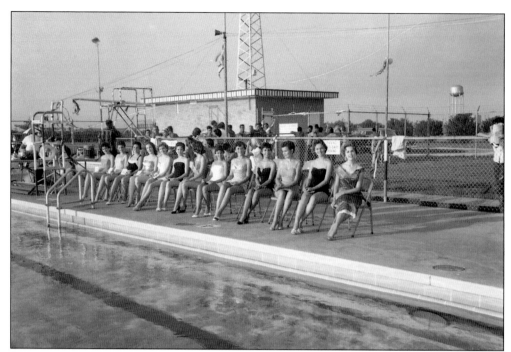

SWIMTIME SWIMSUIT CONTEST, 1957. The municipal swimming pool was the location of the Miss Swimtime Swimsuit Contest of 1957. The contestants are lined up in front of the pool (above). The winner, Quinney Jones, is holding her trophy while posing with the finalists (below).

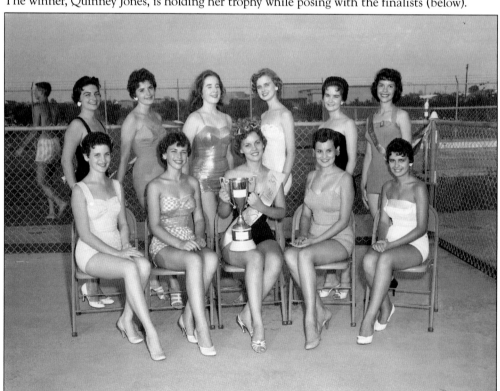

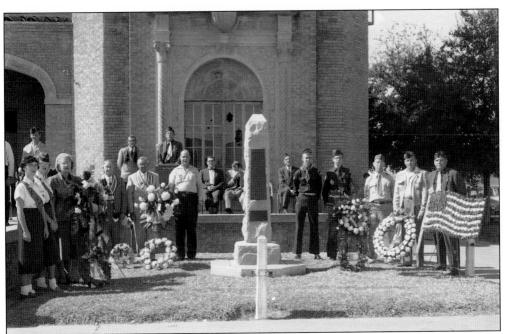

VETERANS DAY MEMORIAL SERVICE, 1955. The old city hall was to be torn down soon, but the 1955 Veterans Day memorial service is being held in front of the beautiful building. Honoring the veterans are members of the American Legion, Veterans of Foreign Wars, Girl Scouts, Boy Scouts, Odd Fellows, and city officials.

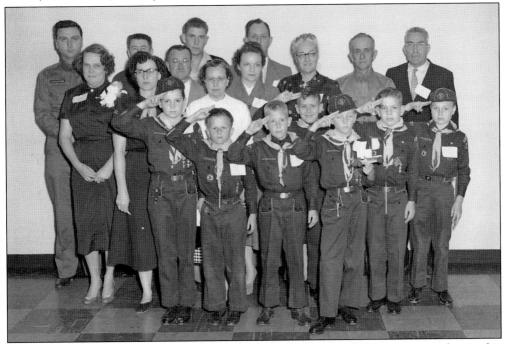

DANFORTH ELEMENTARY CUB SCOUTS, 1957. The Cub Scouts and their parents gather in this photograph. The man in the center of the back row is Rankin Dewalt, police chief for more than 20 years.

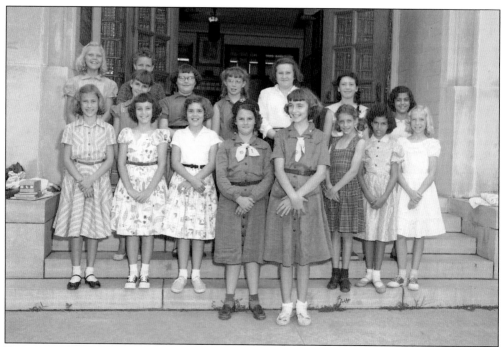

DANFORTH GIRL SCOUTS, 1955. These Girl Scouts are posed in front of Danforth Elementary. A photograph of Dr. Frank Danforth, for whom the school is named, is visible hanging on the wall through the doors. The school closed in the 1970s and eventually became a day care.

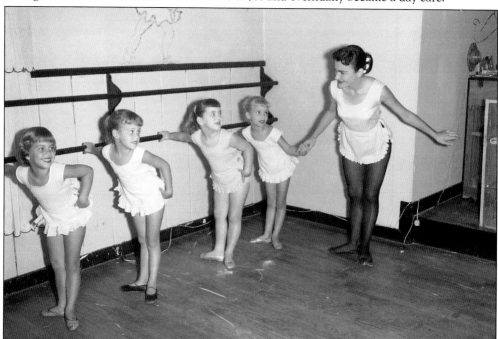

KEHOE DANCERS, 1957. Through the 1950s and into the 1960s, the Vivian Kehoe School of the Dance challenged many girls and boys. Ballet, tap, acrobatic, and adagio were offered for all ages. Vivian Kehoe is coaching four young students.

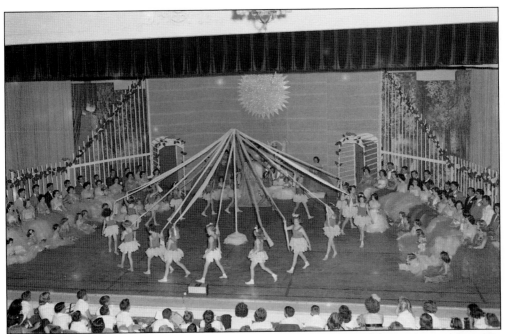

MAY FETE, 1952, 1953. The May Fete has become the social event of the city since it began in 1933. Organizations sponsor duchesses, dukes, and flower girls. The chosen royal court includes a queen, a king, a maid of honor, princesses, and princes. The 1952 court can be seen as the maypole dance goes around (above). The 1953 maypole dancers pause for a photograph (below).

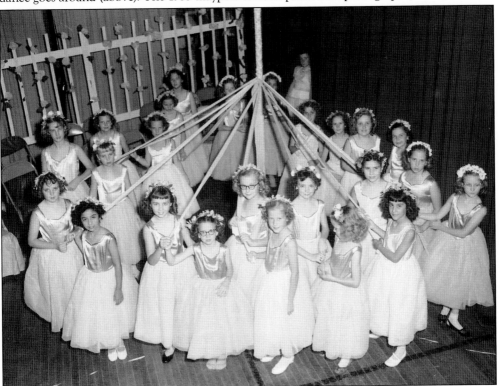

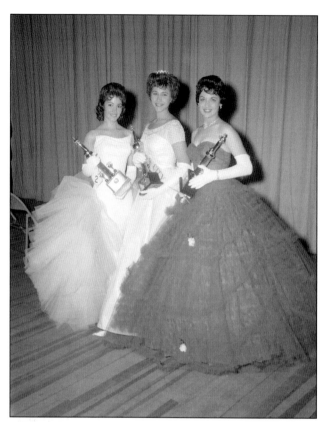

MISS TEXAS CITY PAGEANT, 1961. The 1962 Miss Texas City Pageant was held June 17, 1961, at the high school auditorium with Justin Wilson serving as master of ceremonies. The finalists were, from left to right, Leslie Ann Oakley, Mary Erwin (winner), and Sharelle Pratt. Next was the Miss Texas Contest.

SANTA ON TEXAS AVENUE, 1962. A very phony Santa is entertaining the kids on Texas Avenue in front of Flamingo Lounge. Down the street are T.C. Union Bar, Star Furniture, and Kay's Liquors.

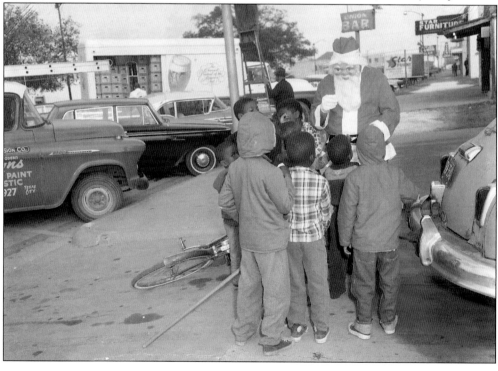

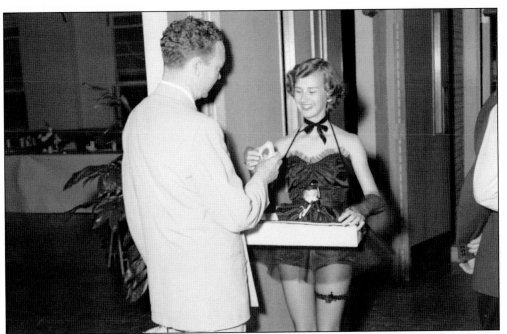

Sweetheart Dance at the High School, 1952. Texas City High School is hosting the Sweetheart Dance at the end of the school year in 1952. A cigarette girl is selling a package of Lucky Strikes to assistant superintendent Ray Spencer (above) and a package of Camels to Texas City High School staff member C.K. Green (below).

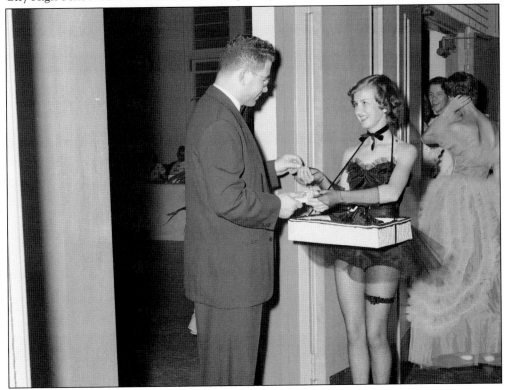

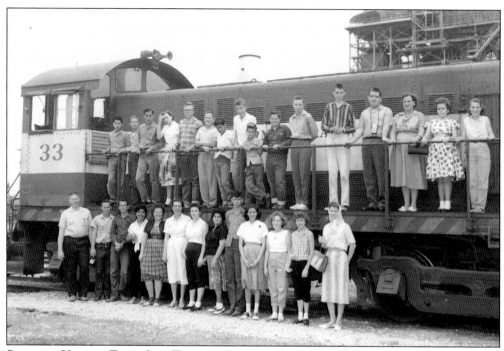

STUDENTS VISITING TEXAS CITY TERMINAL RAILWAY, 1961. Royce White's special education class of Texas City Independent School District (ISD) is visiting a railway company in 1961. Parents are accompanying the class as chaperones.

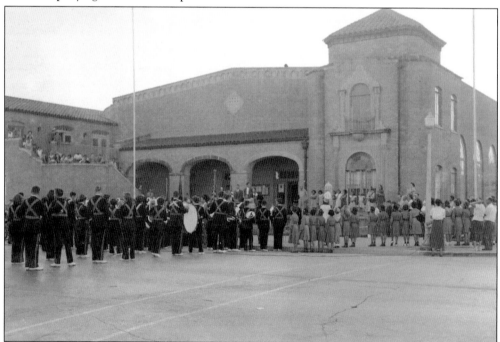

CEREMONY AT CITY HALL, C. 1951. Kids would always climb the steps on the left to get a better view. The music program of Texas City ISD was always willing to perform to support the city. The Girl Scouts of America were there in force, and it was a time of commitment and patriotism.

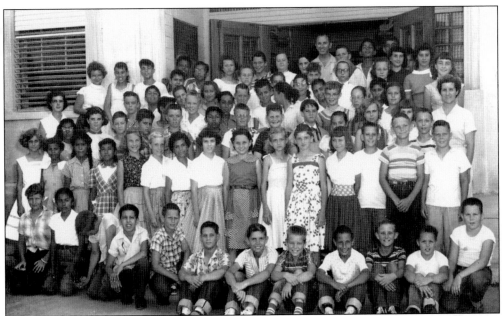

DANFORTH ELEMENTARY SCHOOL AND CHOIR, 1956, 1957. Danforth Elementary was opened in 1938 and was named after Dr. Frank Danforth, a beloved Texas City doctor, who died earlier that year. The sixth-grade class of 1956, with teachers, is gathered in front of the school (above). Below, the Danforth choir of 1957 is on stage at Texas City Junior High under the Yea Demons sign. The Demon was the mascot for Texas City Junior High at the time and later for Blocker Junior High. Danforth Elementary was demolished in 2010.

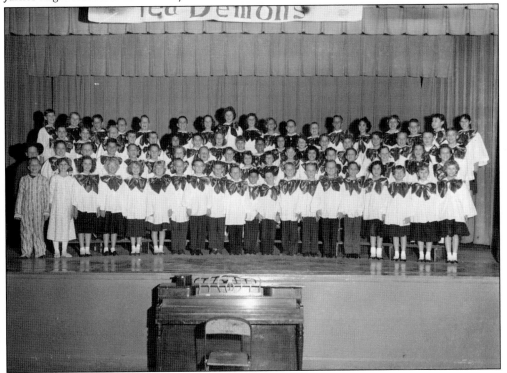

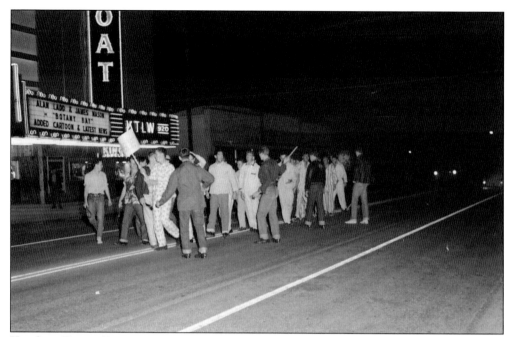

KEY CLUB PAJAMA PARADE, 1953, 1954. For many years, the Key Club of Texas City High required an initiation for new members. Part of this initiation was parading down Sixth Street in pajamas. The photograph above was taken in 1953 in front of the Showboat Theatre. The photograph below was taken in front of the Showboat drugstore in 1954.

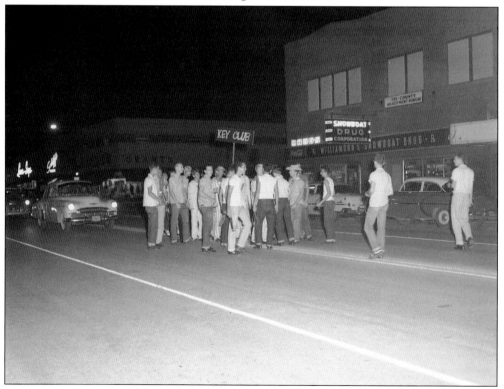

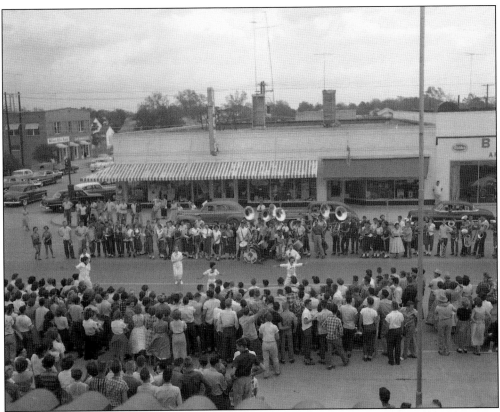

PEP RALLIES, 1954, 1955. Both of these photographs were taken from the old city hall steps. Band director Robert Renfroe can easily be identified holding the megaphone in front of the band (above). In the photograph below, coach Philip Koonce (lower left, walking between the two cars) is working crowd control. Lack's sign can be seen in both pictures.

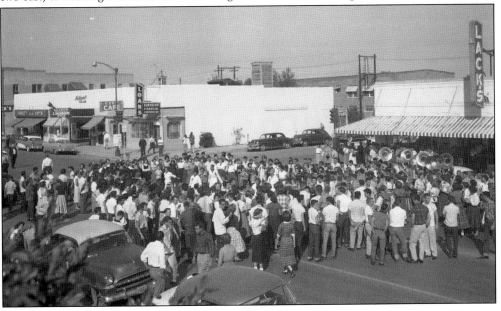

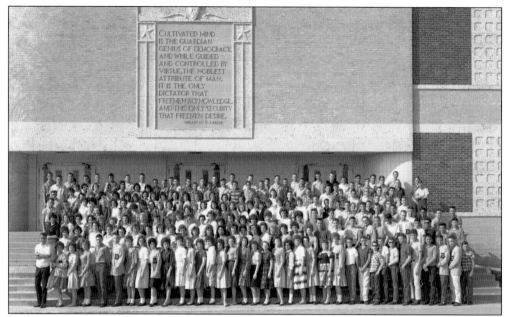

BLOCKER GRADUATING CLASS, 1962. Shown is the ninth-grade class preparing to leave Blocker Junior High to attend Texas City High School in the fall. In a few years, this school will be called Blocker Middle School, and the ninth grade will be moved to high school. Blocker was named after "Uncle Bill" Blocker, a Texas City ISD pioneer, who was the principal and English teacher at both Wolvin and Central High.

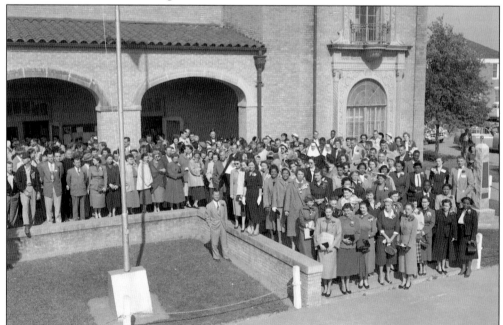

TEACHERS MEETING AT CITY HALL, C. 1951. Teachers from the Texas City Public Schools, including the "colored school," and sisters from Our Lady of Fatima Catholic School have a united meeting at the old city hall. Anyone who attended Texas City schools will recognize many teachers. The purpose of the early 1950s meeting is not known, but everyone dressed nicely for the occasion.

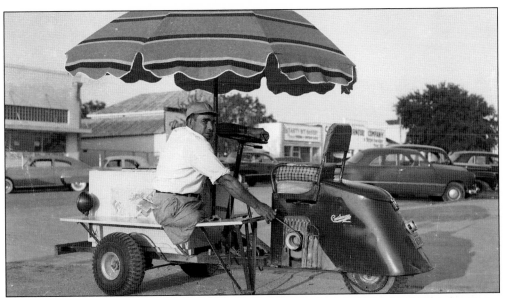

ICE CREAM MAN, C. 1950. Jesse Hernandez was a Texas City resident who lost his legs in an accident at the Texas City Terminal Railway Company. The Texas City Lions Club provided the money to purchase the Cushman and have it modified so that Hernandez could drive it and sell ice cream. The modification was supervised by a paraplegic named Louis Shannon at his business, the Hobby Shop, on Eighth Street and Sixth Avenue.

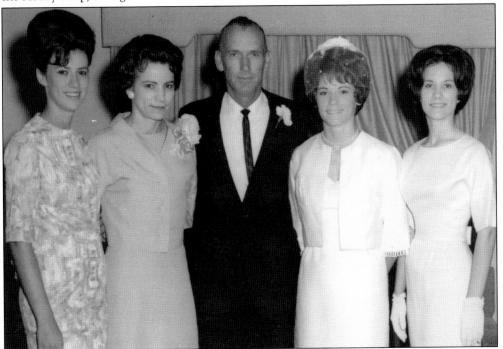

MAYOR WALTER HOLLAND AND FAMILY, C. 1964. Walter Holland served as mayor of Texas City from 1962 to 1964 and previously as city commissioner. He had retired from industry and operated a business. His time of service was after the destruction of Hurricane Carla and during the building of the seawall levee to protect the city from future storms.

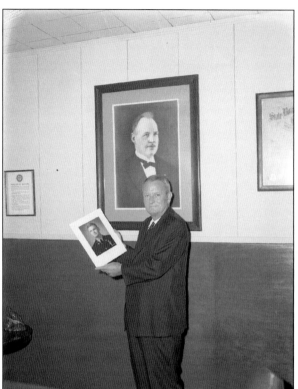

FRED LINTON, C. 1963. Fred Linton is holding a picture of Emken Linton and standing in front of a picture of H.B. Emken. H.B. opened a funeral home in Texas City in 1911. Fred began working for Emken, married his daughter, and after Emken's untimely death in 1943, Fred took over operation of the funeral home. After Fred Linton's death, Emken Linton became the owner and operator of Emken-Linton Funeral Home, which has been an integral part of this community for a century.

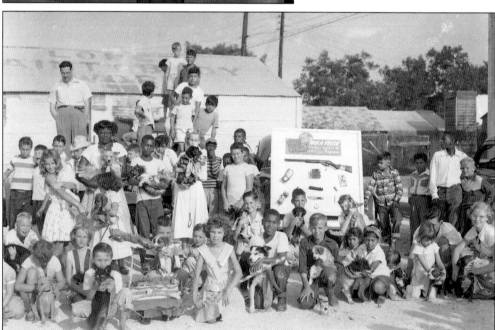

PARD PET PARADE, C. 1951. This photograph was taken in the early 1950s behind Pick and Pay Grocery Store on Texas Avenue. Pard Dog Food sponsored the parade, and prizes were awarded, which are shown on the board. What makes this photograph so unique is the racial integration during a time of racial segregation. The pets created a common denominator.

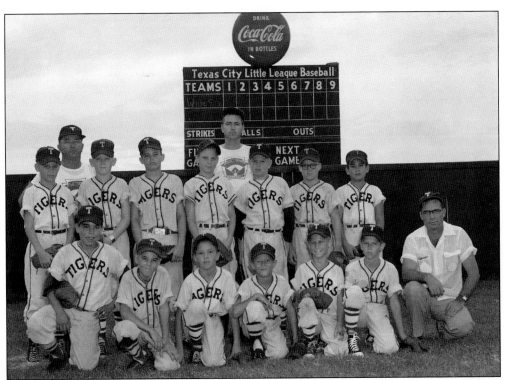

LITTLE LEAGUE, c. 1957. Little League has always been popular in Texas City. Taken at Robinson Stadium in the 1950s, this is one of the many local teams that played over the years.

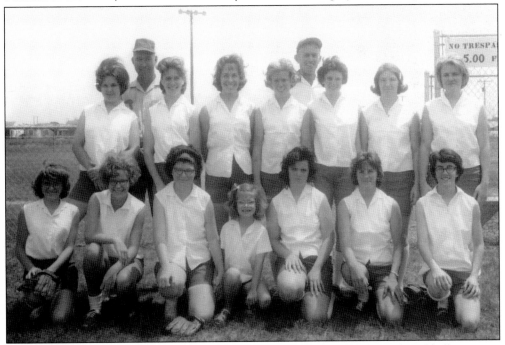

GIRLS' SOFTBALL, c. 1963. Boys had baseball, and girls had softball. This girls' softball team was active in the early 1960s, when this photograph was taken.

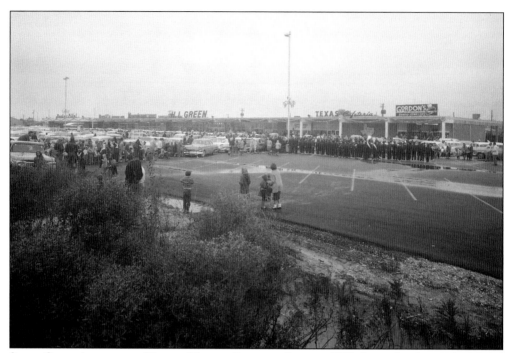

SANTA CLAUS ARRIVING AT HARBOR VILLAGE SHOPPING CENTER, 1959. A crowd and junior high band are waiting for Santa Claus on a cold, wet December day in 1959 (above). It was the first Christmas for Harbor Village Shopping Center. Santa arrives not by sleigh but by helicopter (below).

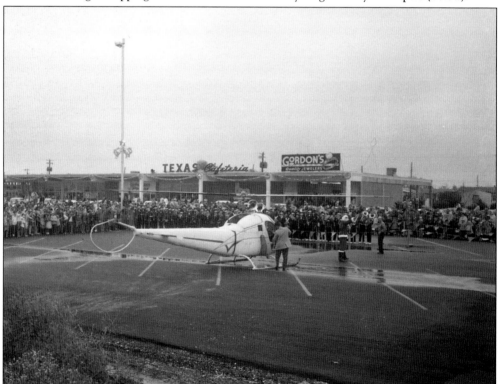

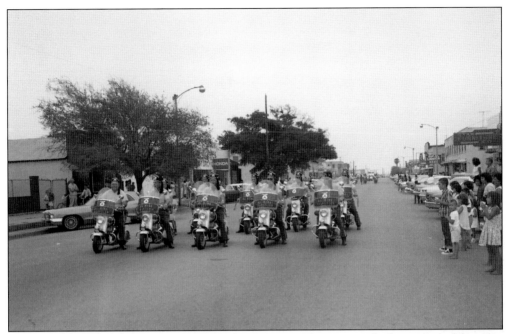

TC Jubilee Parade, 1966. In the 1950s and 1960s, Texas Avenue was the beginning of the route for most parades. The Shriners of the El Mina motorcycle division are performing synchronized maneuvers on their Cushman Eagles. Texas Avenue businesses can be seen, and local kids are on the street watching.

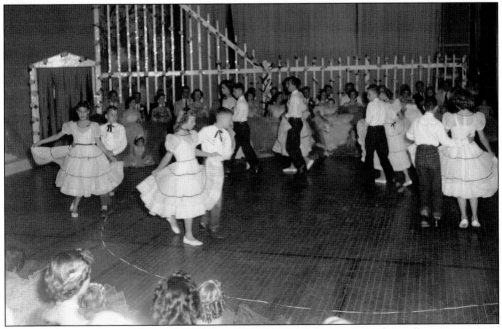

PreTeen Square Dance Club, 1953. Mike Michalke, though not pictured, is calling instructions to his PreTeen Square Dance Club. Taken at the 1953 May Fete, the dancers are Joe Decker, Gaylon Decker, Joe Ball, Darrellyn Sofar, Keith Ball, Martha Decker, David Blackburn, Mary Gilbert, Kenneth Sebesta, Gloria Gilbert, Jeff Bishop, and Dorothy Acree.

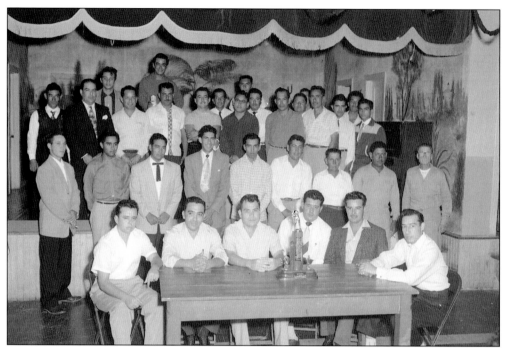

LULAC Baseball District Champions, 1955. This group of men were the League of United Latin American Citizens (LULAC) district champions of 1955 (above). Each of their names is on the trophy. The real supporters of the champions are shown behind the table (below).

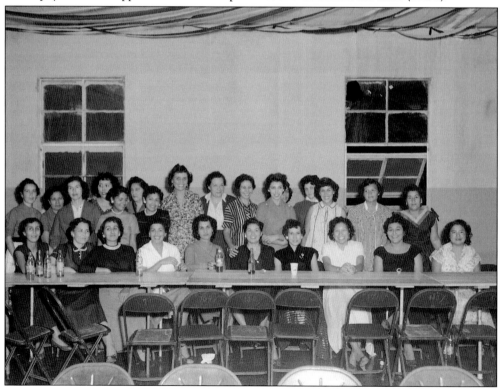

Four

EDUCATION

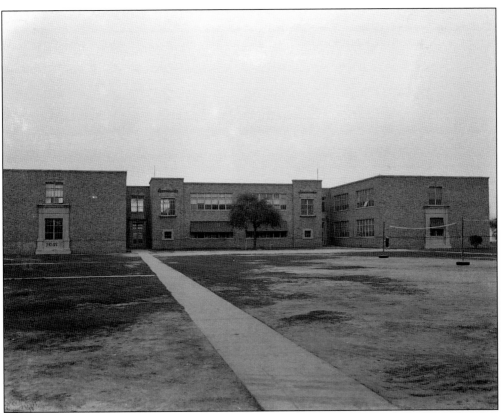

CENTRAL HIGH–TEXAS CITY JUNIOR HIGH, 1956. Central High was Texas City school district's first modern facility. Facing Sixth Street, it opened in 1928. In 1952, a new high school opened on Fourteenth Avenue, and this building became Texas City Junior High. In 1958, a new Texas City High School opened on Ninth Avenue, and the previous high school on Fourteenth Avenue became Blocker Junior High. This building faded into history and was eventually demolished.

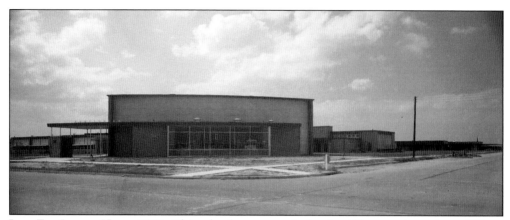

LEVI FRY JUNIOR HIGH, 1955. This school was named after Levi Fry, superintendent of Texas City schools in the 1920s. It opened in the mid-1950s as Levi Fry Junior High. The dragon was the mascot. In the 1970s, the grades were reorganized, and it was renamed Levi Fry Intermediate School. It was demolished to build a new high school in 2009. A new Levi Fry Intermediate School opened on Twenty-fifth Avenue.

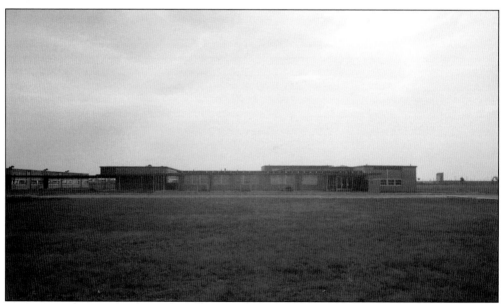

KOHFELDT ELEMENTARY SCHOOL, 1955. The original Kohfeldt Elementary School was built in 1910 at Thirteenth Street and First Avenue South. It was used until 1939 and still stands. The building in the photograph was constructed in the early 1950s on Fourteenth Street and was used until 2009, when it was demolished to build a new high school. A third Kohfeldt Elementary School was opened in 2009 on Thirteenth Avenue.

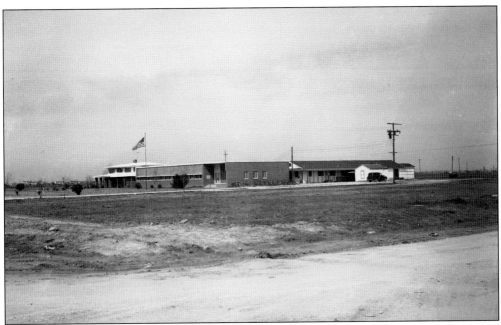

OUR LADY OF FATIMA, C. 1950. Our Lady of Fatima School was founded in 1949 by the Sisters of Charity of the Incarnate Word and St. Mary's Parish. The location was 1600 Ninth Avenue North.

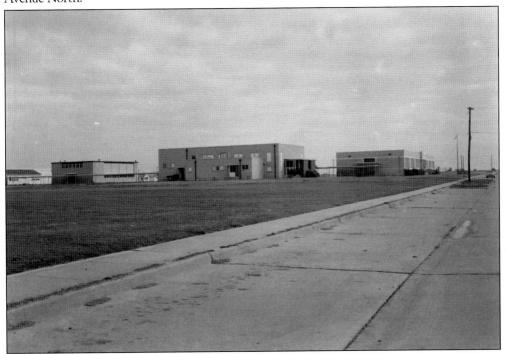

ROOSEVELT WILSON ELEMENTARY SCHOOL, C. 1954. Roosevelt Wilson Elementary was planned and built after World War II. The old buildings have been replaced, but the location is basically the same: on Fourth Street between Fourteenth and Sixteenth Avenues. The grades serviced changed from first through sixth to kindergarten through fourth.

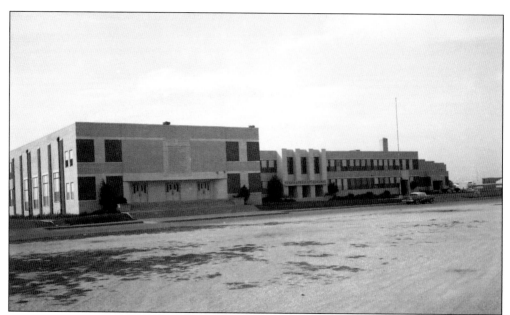

TEXAS CITY HIGH SCHOOL, 1954. Texas City High School opened here, at 500 Fourteenth Avenue North, in 1952. In 1958, a new high school opened on Ninth Avenue, and this building became Blocker Junior High. It became Blocker Middle School in the mid-1970s, when grades were reorganized. It was named after "Uncle Bill" Blocker, a beloved principal and English teacher.

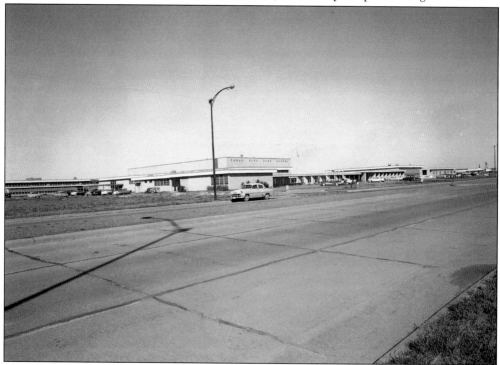

TEXAS CITY HIGH SCHOOL, 1958. The presently used Texas City High School, at 1800 Ninth Avenue North, was opened in 1958. H.B. Landers was principal during the move from Fourteenth Avenue to Ninth Avenue. He was principal of Texas City High School for 24 years.

Five

RELIGIOUS OBSERVANCES

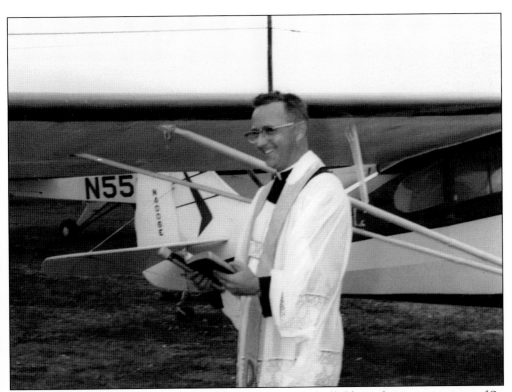

BLESSING PLANES AT WAGES AIRPORT, 1962. Rev. Edward Sheffield was the assistant pastor of St. Mary's Catholic Church in Texas City. He loved airplanes and flying. In this photograph, he is shown blessing the planes before flight. On May 15, 1962 (16 days later), he and three other men took off from Wages Airport and soon crashed off Highway 146. All were killed.

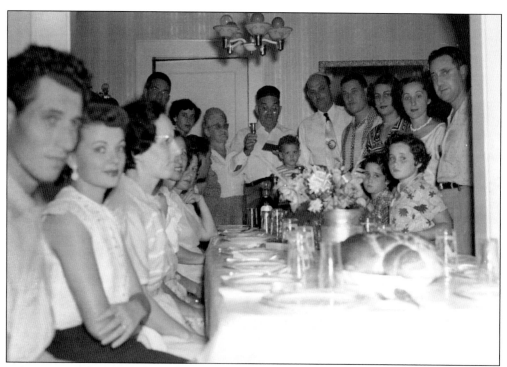

SABBATH MEAL OBSERVANCE, c. 1950. A prominent Jewish family in Texas City is enjoying their freedom of worship by observing the Sabbath meal.

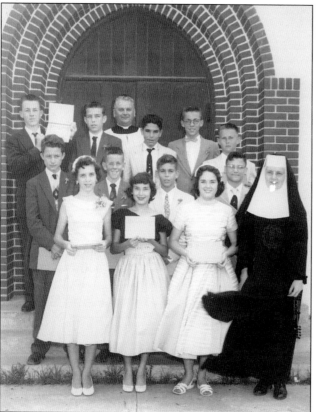

SAINT MARY'S CATHOLIC CHURCH YOUTH, c. 1956. The youth are standing on the steps of the building erected in 1944, after the 1943 hurricane destroyed the previous building. This structure, at 724 Third Avenue North, was used until a new facility was recently dedicated on Ninth Avenue.

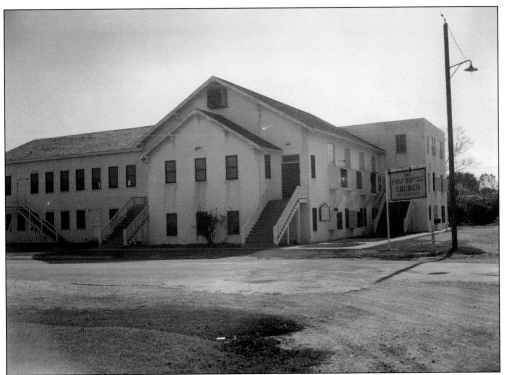

FIRST BAPTIST CHURCH, C. 1953. First Baptist Church was organized in 1905. This building was dedicated in 1937, with two charter members present. Only 10 years later, 42 members were killed in the explosion of 1947.

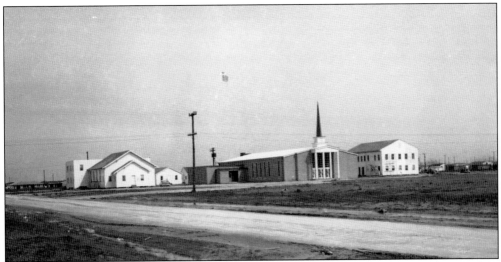

FIRST BAPTIST CHURCH, 1955. The last living charter member was present to break ground for this new worship facility in 1954, and the formal dedication service was held March 6, 1955. The white structures were temporary and were eventually replaced by permanent buildings.

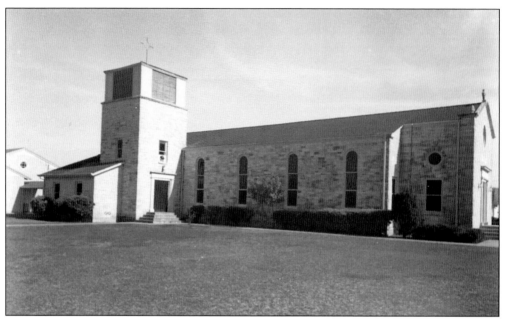

FIRST METHODIST CHURCH, C. 1955. The church began with informal meetings in 1894. The First Methodist Church was formed in 1938, and this building was erected in 1940. In 1968, the church was renamed the First United Methodist Church.

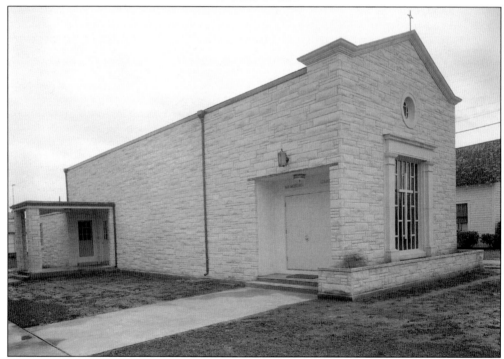

STEED MEMORIAL CHAPEL, 1958. Mr. and Mrs. W.C. Steed donated the money to build Steed Memorial Chapel in memory of their son Jimmy, who was lost in a diving accident. The chapel was built in 1958, next to the First Methodist Church. W.C. was the mayor of Texas City from 1947 to 1948.

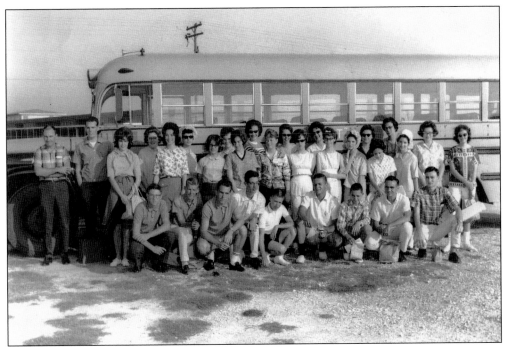

FIRST BAPTIST CHURCH YOUTH, 1964. This group of young people and four adult leaders are leaving for the Baptist Youth Festival at Six Flags in Dallas. Notice the non–air-conditioned school bus.

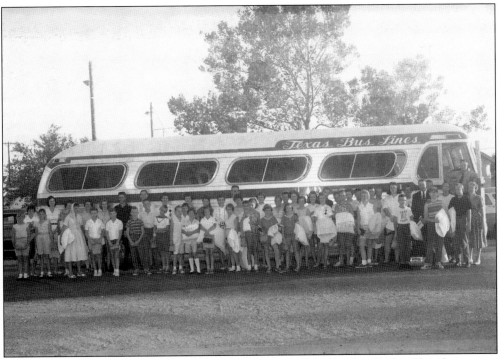

FIRST METHODIST CAMPERS, 1959. These young members of the First Methodist Church are going on an overnight trip. Notice the pillows and sack lunches and the air-conditioned charter bus.

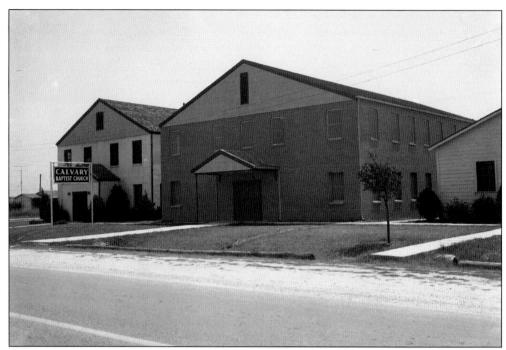

CALVARY BAPTIST CHURCH, C. 1962, C. 1964. Calvary Baptist Church was meeting at 517 Eighteenth Avenue, in the early 1950s (above). Church members still meet there today. Below, the church is sponsoring a Girls' Auxiliary Coronation ceremony in the mid-1960s, which is a way for young girls to be recognized for learning about missions and Baptist doctrine while memorizing scripture.

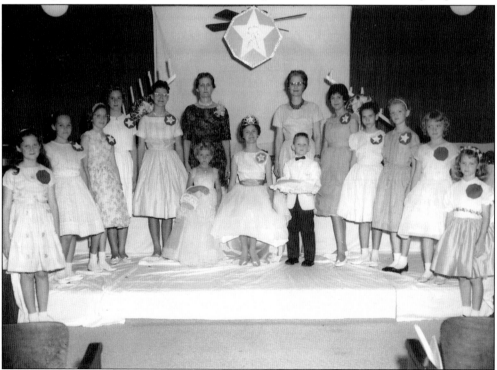

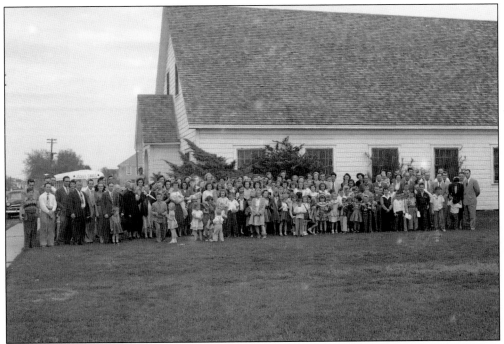

FIRST ASSEMBLY OF GOD CHURCH, 1953. The First Assembly of God Church was meeting at this location, 224 Fourth Street North, by 1943. By 1963, the church was at its new location at Twenty-first Avenue and Sixth Street.

MEMORIAL LUTHERAN CHURCH, C. 1956. Memorial Lutheran Church was formed in 1944, during World War II. The church moved to this building, at 402 Ninth Avenue North, in the early 1950s and stayed there until 2004 when the building was destroyed by fire. A new building on Twenty-ninth Street was dedicated in 2006.

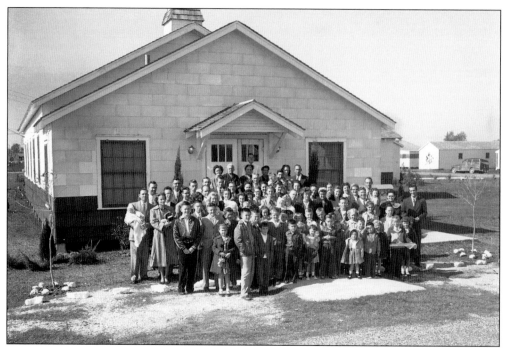

UNITED PENTECOSTAL CHURCH, 1953. The United Pentecostal Church was worshipping at this location at 719 Twenty-Second Street North by 1953. Worshippers, with Bibles in hand, gather on a cold November Sunday morning.

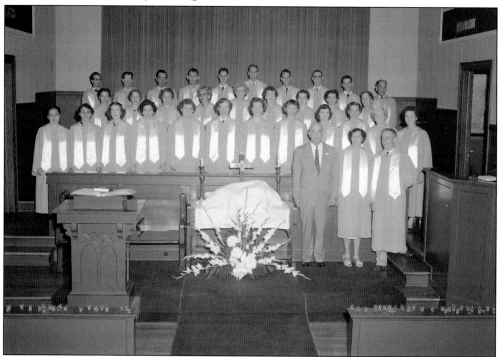

FIRST METHODIST CHOIR, 1955. Pictured is the choir on a Sunday morning after the worship service. The communion cups are still fresh on the altar.

Six

LOCAL GOVERNMENT

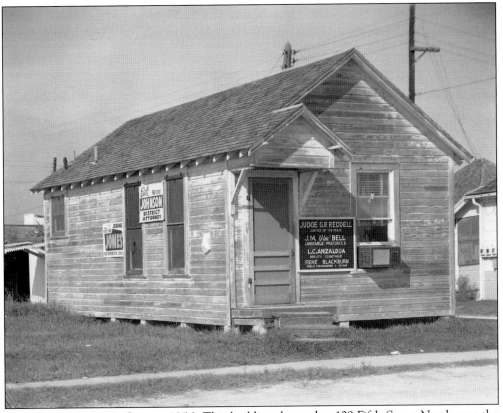

JUSTICE OF THE PEACE OFFICE, 1956. This building, located at 109 Fifth Street North, was the office of G.P. Reddell, justice of the peace, and Jim Bell, constable, through the 1950s until the Mainland County Building was constructed in 1958.

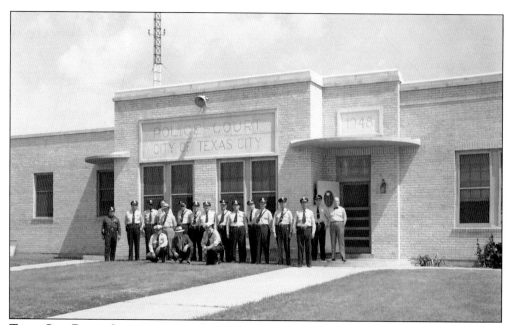

TEXAS CITY POLICE STATION, 1955. The Texas City Police Station was built in 1948, shortly after the explosion of 1947. The police force was small, but the crime rate was also small, and everybody felt safe. Before the explosion, the police chief's office and the jail were housed in the old city hall. Damage from the explosion forced the police department to build its own structure. Most of the 1955 department are in the photograph above. Below, police officers are interacting with local youth.

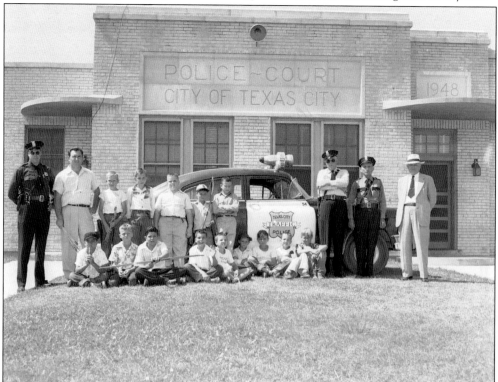

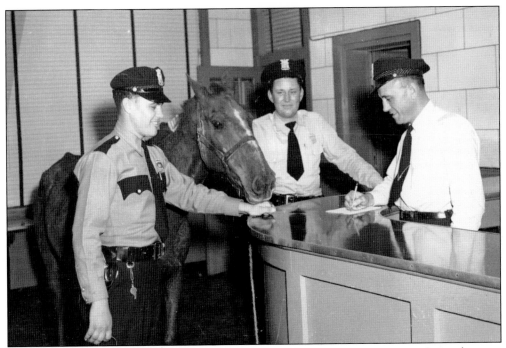

POLICE ARRESTING HORSE, C. 1955. The story is lost to history, but these Texas City policemen are booking a horse in the old police station at 916 Fifth Avenue North (above). Whether a misdemeanor or felony, this horse is going to jail (below).

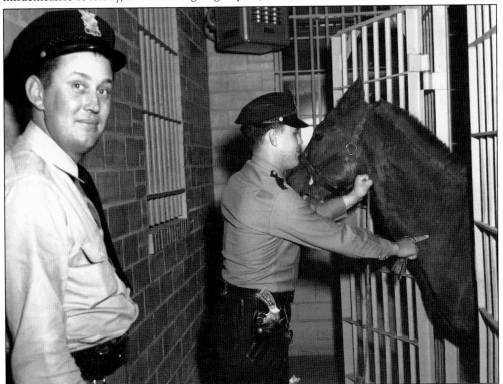

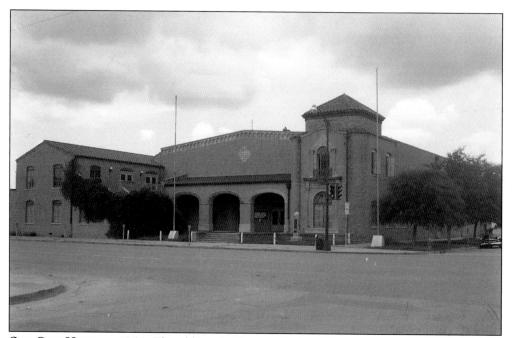

OLD CITY HALL, C. 1955. The old city hall was built in 1928 at a cost of $250,000. It was a combination city hall and civic auditorium, and it was the central meeting place for everything imaginable. The police department and jail were housed here. This beautiful building was heavily damaged by the disaster of 1947, but it was still used until 1956 when it was torn down.

NEW CITY HALL, 1955. The new city hall was constructed under the administration of Mayor Lee Robinson in 1955. The old city hall on Sixth Street, despite its beauty, was archaic and could not be expanded. Moving into this building was a giant step in the right direction for the growing city.

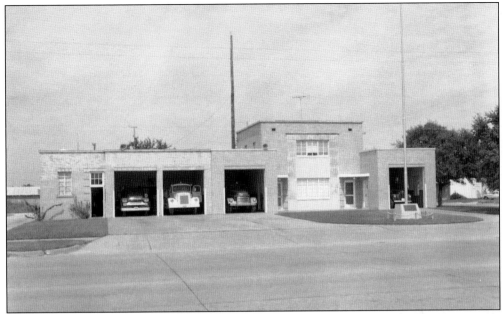

FIRE STATION ONE, C. 1955. Fire Station One, or Central Fire Station, was built after the explosion of 1947, in which most of the volunteer firemen were lost, and all of the fire equipment was destroyed. It would house a new volunteer department with new volunteers. The fire department was chartered in 1911 and remained a volunteer unit until 1955 when the city organized a paid fire department.

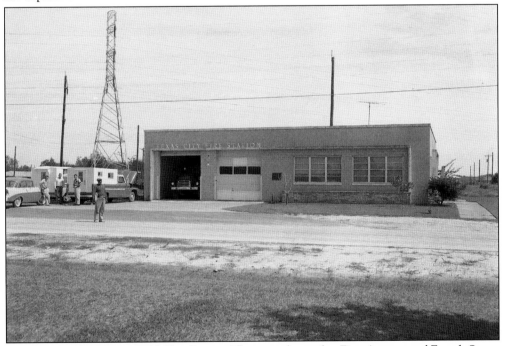

FIRE STATION THREE, C. 1955. Fire Station Three was located at First Avenue and Fourth Street South, closer to the industrial area. Fire Station Two was the Heights Fire Department, located at Texas Avenue and Logan Street. All of these buildings have been demolished.

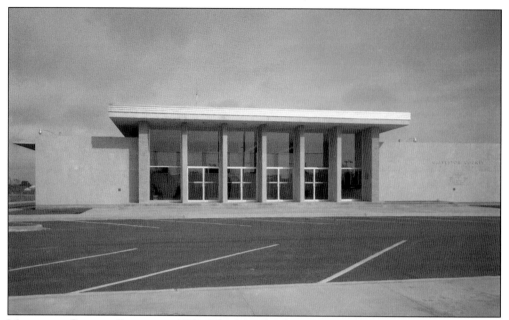

MAINLAND COUNTY BUILDING, 1958. The Mainland County Building at 2600 Texas Avenue opened in 1958. It gave offices to the tax assessor and collector, justice of the peace, constable, county commissioner, assistant county probation officer, juvenile officer, district attorney, sheriff's department, veterans' services, family welfare services, state welfare department, automotive department, division of civil defense and disaster relief, and it held the courtroom.

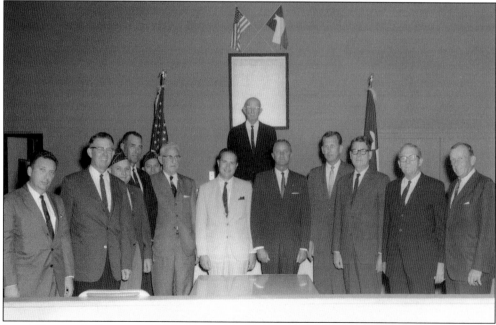

JUDGE REDDELL'S COURT, c. 1964. G.P. Reddell, justice of the peace, is in his court with several recognizable individuals. Constable Jim Bell is fourth from left. County judge Pete LaValle and county commissioner Jack Lawrence are number seven and eight from the left, respectively. Mayor Emmett Lowry is to the right of Commissioner Lawrence.

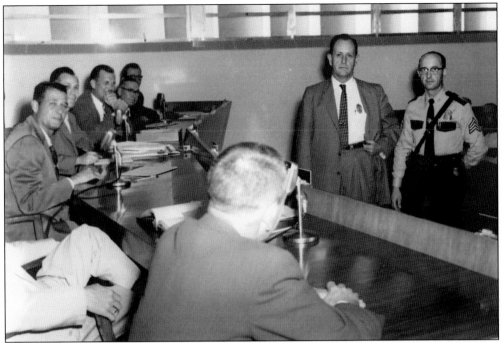

MAYOR GODARD PRESIDING IN CITY HALL, C. 1958. Mayor Jack Godard, far left, and his council are handling city business, and Chief Rankin Dewalt and an officer are addressing the council. It appears that commissioner and future mayor Emmett Lowry is amused at something in the council room.

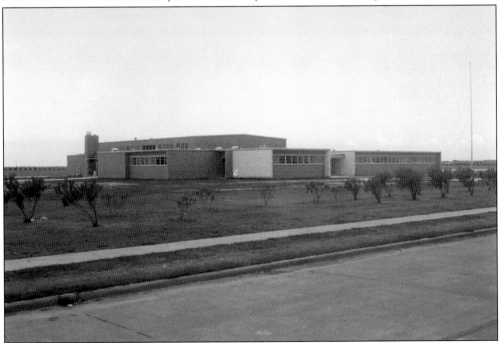

CIVIC CENTER, 1956. The Carl Nessler Civic Center was completed in 1955, five years after the parks and recreation department was instituted. The original location was the old city hall on Sixth Street. The center was the first of many ongoing recreational facilities.

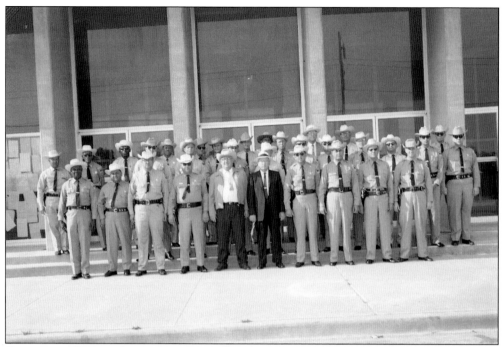

GALVESTON COUNTY SHERIFFS, 1962. Galveston county sheriffs are standing in front of the Mainland County Building at 2600 Texas Avenue North (above), and they are standing by their cars (below). Directly behind the cars is the Heights Volunteer Fire Department.

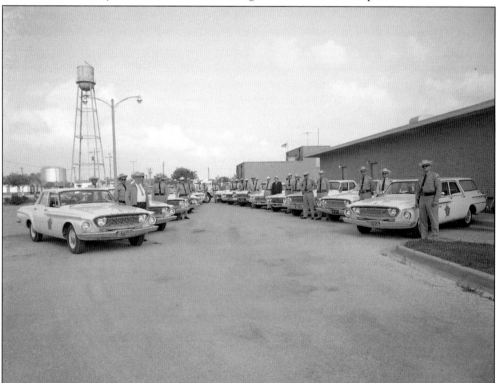

Seven

The Dike

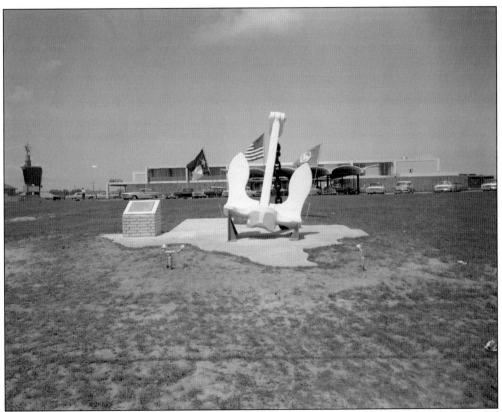

Holiday Inn, 1962. The Holiday Inn had 72 rooms and was built with the support of 1,400 local stockholders. It was to open late in 1961, but Hurricane Carla damaged much of the new structure. It was built where the US Air Force had its birth in 1913.

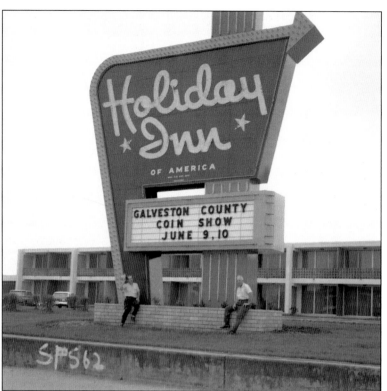

HOLIDAY INN, 1962. Because the Holiday Inn was to be built outside of the 1932 seawall, the land was raised to the seawall level. The insignificance of the old seawall was brought to light by Hurricane Carla as the hotel attempted to open. The Holiday Inn reopened after the storm and operated until the 1980s.

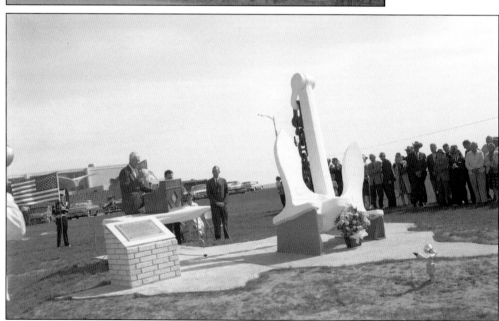

GRAND CAMP ANCHOR, 1962. This photograph shows the dedication of the anchor from the *Grand Camp*, which exploded 15 years earlier. Speaking is J.C. Trahan, mayor of Texas City during the disaster of 1947, and Walter Holland, mayor at the time of the dedication, stands left of the anchor. The photograph was taken on April 16, 1962. The new Holiday Inn is seen behind the speaker. The area is now a park.

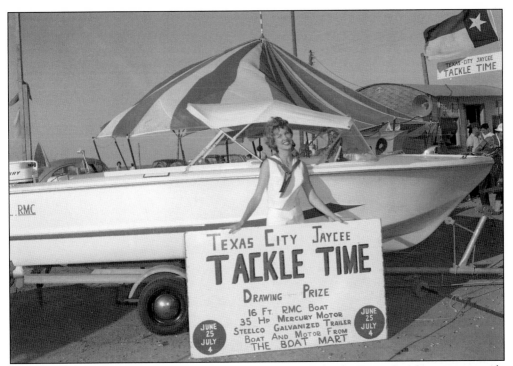

TACKLE TIME, 1960, 1962. Tackle Time was started in 1953 by the Texas City Jaycees, primarily as a fundraiser. It soon became known as the greatest fishing contest on the Gulf Coast. In 1960, a young lady stands in front of a boat and motor, which will be given away at a drawing (above). Besides the fishing contest, a Miss Tackle Time Contest was sponsored, which was a preliminary to the Miss Texas Pageant. The Jaycee-Ettes, or Jaycee wives, assisted their husbands and sponsored other projects (below).

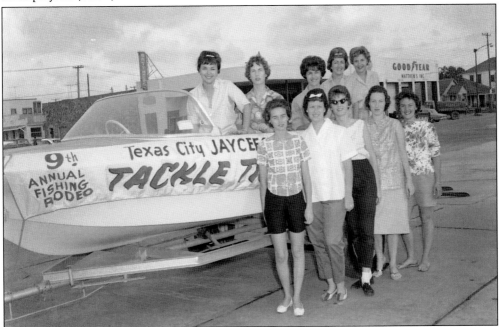

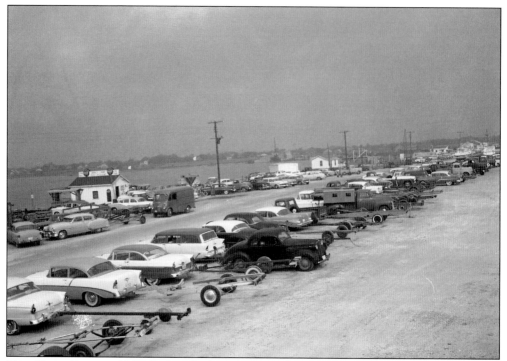

DIKE ROAD CARS, C. 1957. Before the levee was a reality, the city could be seen from the dike. Each trailer represents a boat in the water, so the bay must be filled with seacraft.

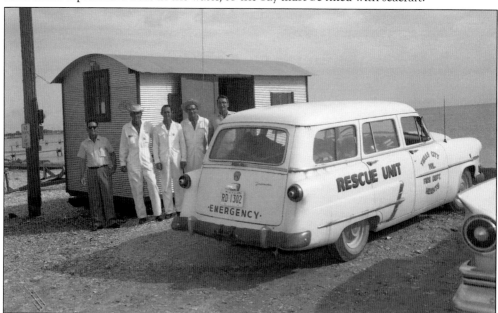

TEXAS CITY VOLUNTEER FIRE DEPARTMENT RESCUE UNIT, 1961. The purpose of the rescue unit was to rescue boats and their passengers who were stranded in Galveston Bay. Each of the volunteers owned a boat and remained on call 24 hours a day. The waters around the Texas City dike were dangerous, and accidents were common. Often, volunteers were required to pull drowning or drowned victims from the water.

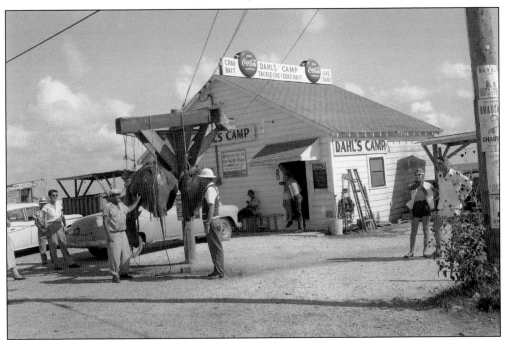

DAHL'S CAMP, 1960, 1961. The effects of Hurricane Carla can be seen in these two photographs. The image above was taken in July 1960 during the Tackle Time Contest. Prizes are awarded for catching the largest fish in several categories. The photograph below was taken September 1961. Most of the buildings were washed away. The Texas City Dike was "cleaned" again during Hurricane Ike in 2008.

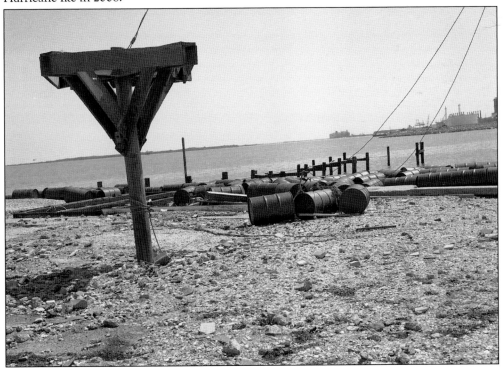

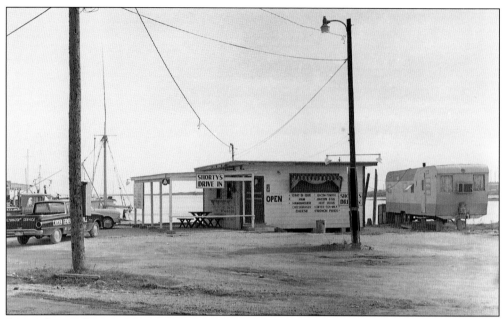

SHORTY'S AND SURFSIDE DRIVE-INS, 1964, 1964. At these two drive-ins, fishermen and tourists could satisfy their dining needs without leaving the dike. Shorty's (above) operated from the early 1950s until after 2000. Surfside was opened before Hurricane Carla and stayed through the 1960s (below). Both survived and rebuilt after Carla, but Shorty's was closed by Hurricane Ike.

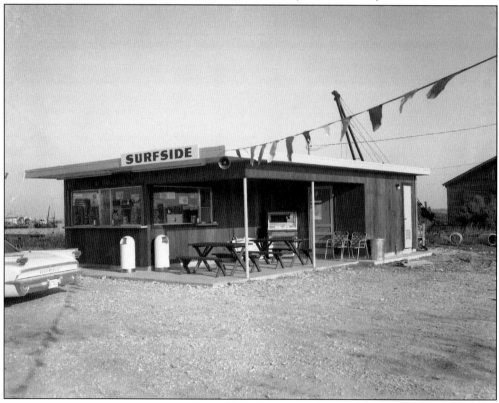

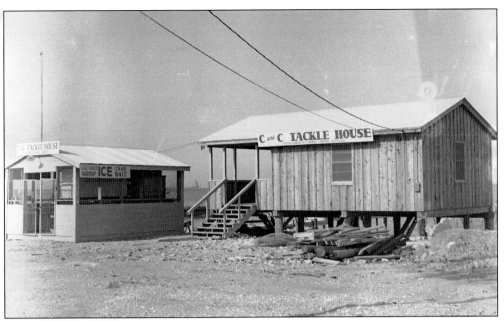

C AND C TACKLE HOUSE AND SIMPSON'S BAIT CAMP, 1964, 1964. C and C Tackle House (above) opened in the early 1960s and was still open in the late 1970s. It advertised ice, live and dead shrimp, and tackle. The aroma of the bait house is not easily forgotten. Simpson's Bait Camp (below) opened before Hurricane Carla and was still operating in the early 1970s. It rented dip nets and poles, as well as bait, ice, and tackle.

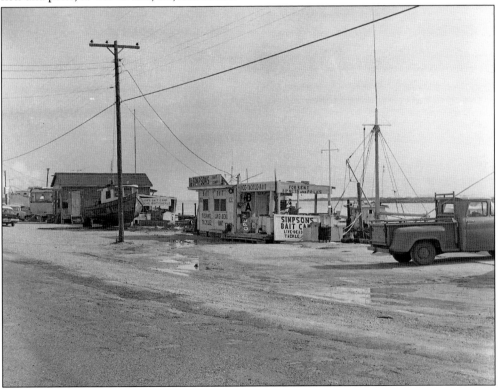

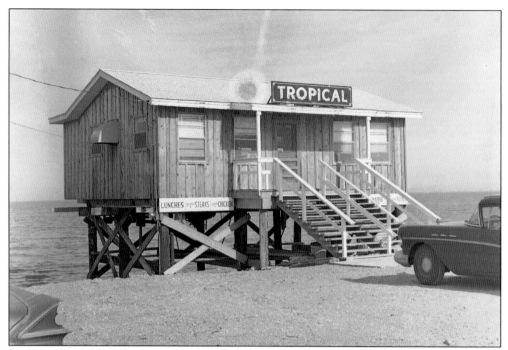

TROPICAL RESTAURANT, 1964. Adjacent to the dike's first long pier was the Tropical Restaurant, owned by Charlie and Irene Angelos. It was known for its great view of Galveston Bay and tasty fish platters. The Tropical opened in the mid-1950s and survived Hurricane Carla—at least parts of it did. It closed around 1970, and the building was eventually torn down.

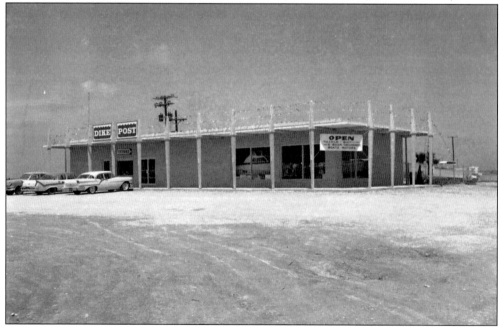

DIKE POST, C. 1958. The Dike Post is believed to have been opened before Hurricane Carla and destroyed by the storm. It sat at the end of the dike and sold boats and motors. The foundation is all that remains.

Eight

INDUSTRY

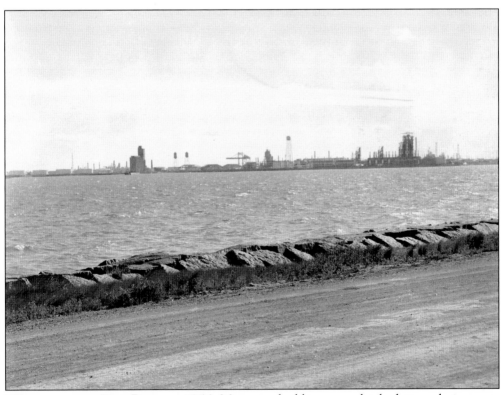

MONSANTO FROM DIKE ROAD, C. 1956. Monsanto had been completely destroyed nine years before this photograph was taken. A large percentage of the employees were killed or injured, and all of the buildings were destroyed in the explosion of the *Grand Camp*. Management said it would rebuild, and it did.

Two Ms of Six Street, c. 1960. There appears to be a measure of industrial competition in the two Ms facing each other. Monsanto was in Texas City first, but Marathon is still on the job as Marathon.

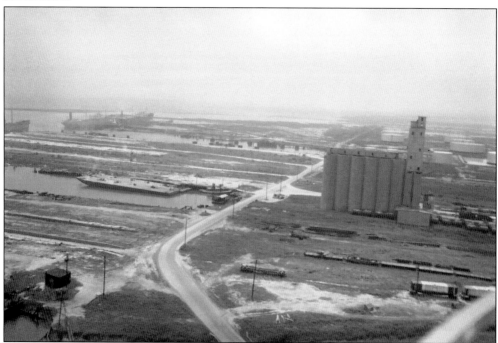

Grain Elevator, 1953. This 500,000-bushel-capacity grain elevator was built in 1909 and was one of Texas City's flourishing industries until it was virtually destroyed in the 1947 explosion. It remained a visual casualty until 1957 when it was demolished.

HARBUR TERMINAL CO., 1961. Harbur Terminal was a steel drum storage and filling service for petroleum and chemical products. In September 1961, there were 700,000 steel 55-gallon drums stacked neatly in its port facility. Hurricane Carla picked up 450,000 of those drums and scattered them across 20 square miles. In the above photograph, they are stacked, and in the photograph below, drums are all along Sixth Street. After a three-month-long drum roundup, only one percent of the drums were still lost.

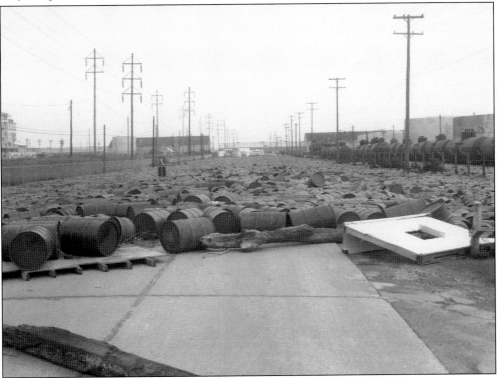

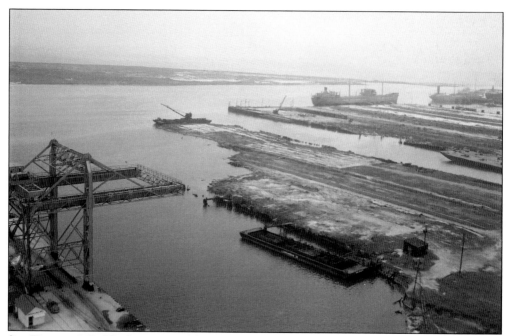

SEA TRAIN, 1953. The large crane lifted train cars from the track to be loaded onto ships, which was a precursor of the containerization process used today. The barge is moored at the location of the *Grand Camp* six years earlier. The *High Flyer*, the other ship that exploded, was docked at the slip on the right.

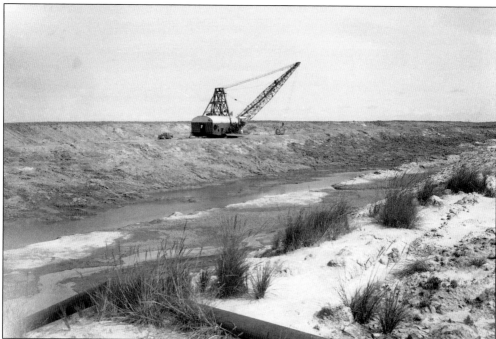

SEA WALL LEVEE CONSTRUCTION, 1964. This gigantic dragline was used to build the new levee after Hurricane Carla. It had no wheels or tracks but walked on giant feet at a snail's pace. It arrived at Dollar Point on a barge and departed the same way.

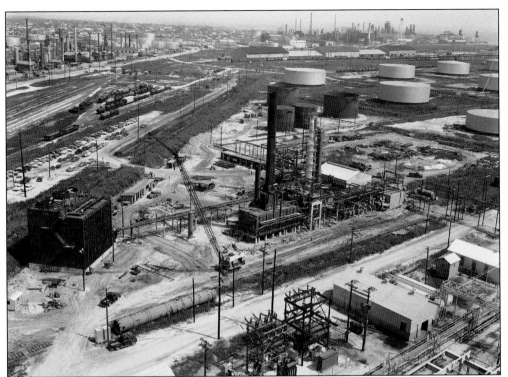

PLANT CONSTRUCTION, C. 1958. Taken from a tower at Texas City Refinery, TCR is experiencing new construction, and Texas City Terminal Railway is seen skirting the plant. To the upper left is Republic Oil Company, now Marathon Oil Company, and to the upper right is Monsanto Chemicals, now Sterling Chemicals.

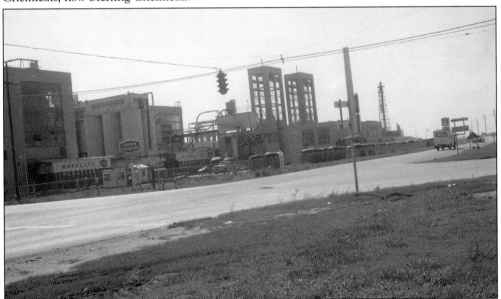

UNION CARBIDE, C. 1958. Union Carbide Chemicals Company came to Texas City in 1941. In 2001, Union Carbide became a subsidiary of Dow Chemical Company, and the name was changed. The area looks nothing like this now.

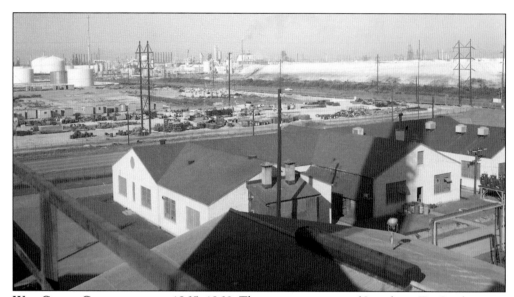

WAH CHANG CORPORATION, C. 1965, 1968. The government-owned Longhorn Tin Smelter went into operation in 1942. It produced tin ingots until 1989, and copper smelting continued for a couple of years. At one time, the plant generated 45 percent of the world's production of tin. In 1958, Wah Chang Corporation purchased the facility and adapted it for manufacturing tungsten products and tin alloys. The facility changed hands two more times and was ultimately named the Tex-Tin Corporation, which ceased operations in the 1990s. The EPA listed the site on the Superfund's National Priority List in 1990, and after extensive clean up, it was issued the first Ready for Reuse determination in the nation. A view of the industrial area (above) is seen from a Wah Chang tower with Union Carbide Chemicals, now Dow Chemicals, at left and American Oil Company, now British Petroleum, at right. Tin ingots are displayed by an employee (below).

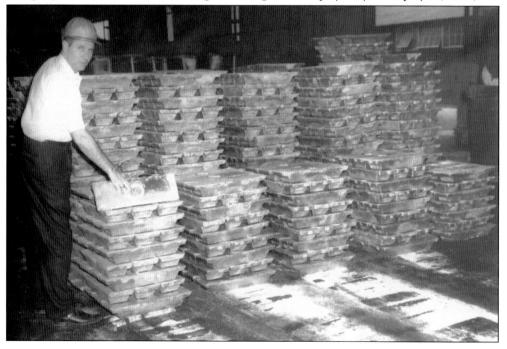

Nine

MISCELLANEOUS

KENNETH T. NUNN HOUSE, C. 1955. This house, with its outstanding architecture, was built on Bay Street with a panoramic view of Galveston Bay. The levee took away that view in 1962. Kenneth T. Nunn served as the city secretary for Texas City for 45 years. Following his retirement, the city council chambers were renamed the Kenneth T. Nunn Council Chambers in his honor.

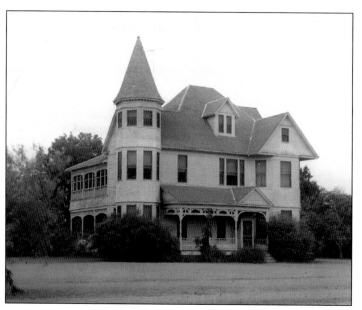

DAVISON HOME, c. 1955. The Frank B. Davison Home was built in 1897. Davison was hired to oversee the developing of a port and industrial center at Shoal Point (Texas City). He became the first postmaster of the newly named community of Texas City in 1893. The Davison Home is now part of the Texas City Historical Preservation Corporation.

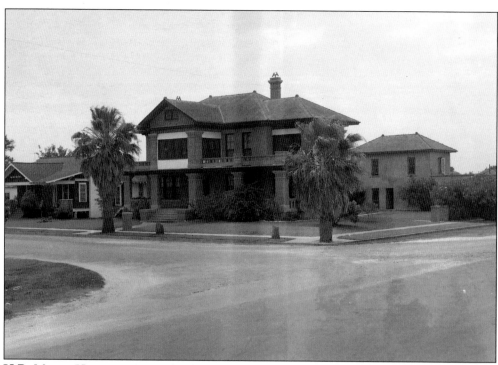

H.B. MOORE HOUSE, c. 1955. Col. H.B. Moore built this house at 8 Ninth Avenue North in 1912. He wore many hats in early Texas City. He managed the Texas City Terminal Railway Company, the Wolvin Steamship Lines, the Texas City Transportation Company, and the Mainland Company. He was the director of Army transports in World War I and helped in building the dike, enlarging the port, and bringing industries to Texas City. The walls of this home have 13-inch walls reinforced with railroad rails. Thus, it withstood the 1915 Hurricane and the disaster of 1947.

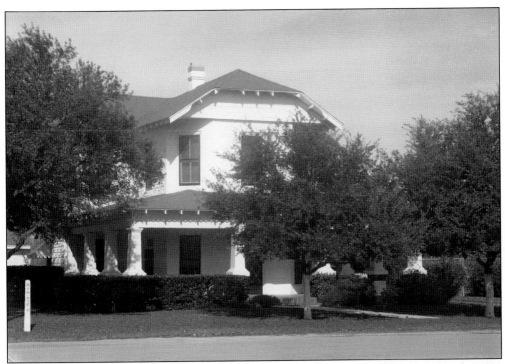

W.P. Tarpey House. W.P. Tarpey was the first mayor of Texas City and served from September 1911 to December 1912. This house was built by 1910 and still stands at 132 Eighth Avenue North.

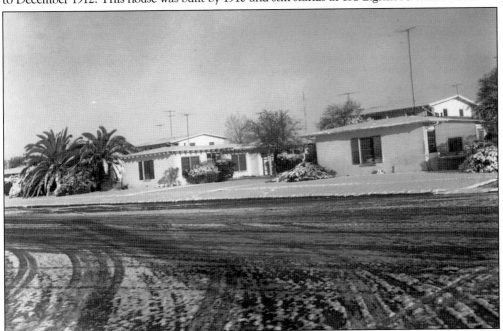

Third Avenue Villas, 1960. Third Avenue Villas, built and landscaped in 1943, was the first housing project in Texas City. The streets and yards are white as it was the first snowfall in more than a decade. It was snowing measurably when school was dismissed on Friday, February 12, 1960. The snow lasted all weekend.

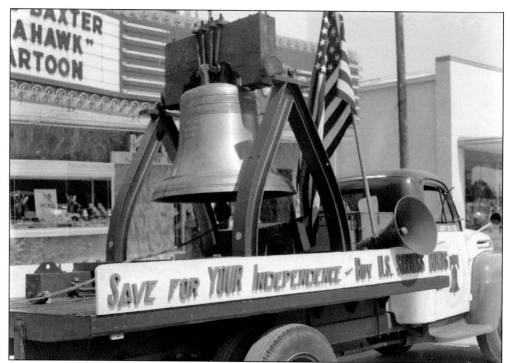

LIBERTY BELL REPLICA, 1950. The location of this photograph is 416 Sixth Street North, in front of the Showboat Theatre. In 1950, the US Department of the Treasury, assisted by several private companies, selected Paccard Foundry in Annecy-le-Vieux, France, to cast 55 full-sized replicas of the Liberty Bell. Each state and territory received one. It was part of a national drive to sell US savings bonds. This bell is at Texas A&M University.

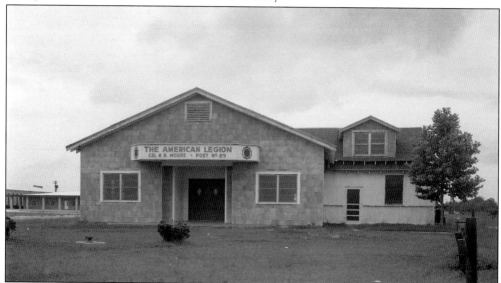

COLONEL MOORE AMERICAN LEGION HALL, c. 1956. The American Legion of Texas City, located at 1510 Ninth Avenue North, was named after Col. H.B. Moore, the director of Army transports in World War I and an early Texas City visionary and businessman. By 1958, Post No. 89 had moved to a new location at 3028 Twenty-Ninth Street North.

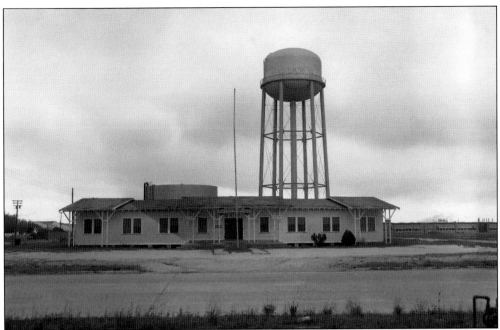

VFW HALL, 1956. The Veterans of Foreign Wars Mainland Post 3216 was located at 1507 Ninth Avenue North. The actual location would be on the present stadium parking lot.

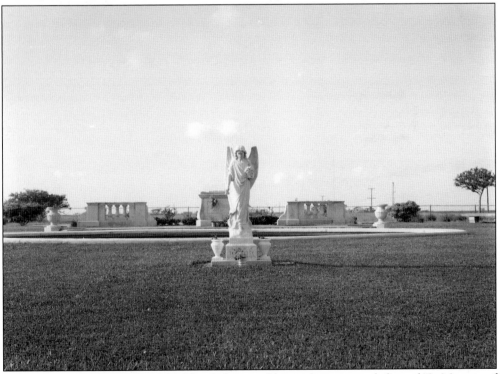

FIREFIGHTERS MEMORIAL, c. 1956. This Italian marble angel statue was dedicated "In Memory of Texas City Volunteer Fireman" who were lost in the Texas City Disaster of 1947. She no longer sets on land but is in the middle of a pool surrounded by water spouts.

DISCOVER THOUSANDS OF LOCAL HISTORY BOOKS FEATURING MILLIONS OF VINTAGE IMAGES

Arcadia Publishing, the leading local history publisher in the United States, is committed to making history accessible and meaningful through publishing books that celebrate and preserve the heritage of America's people and places.

Find more books like this at
www.arcadiapublishing.com

Search for your hometown history, your old stomping grounds, and even your favorite sports team.

Consistent with our mission to preserve history on a local level, this book was printed in South Carolina on American-made paper and manufactured entirely in the United States. Products carrying the accredited Forest Stewardship Council (FSC) label are printed on 100 percent FSC-certified paper.

MADE IN THE

USA